W9-BMM-342

Newportraits

Newp

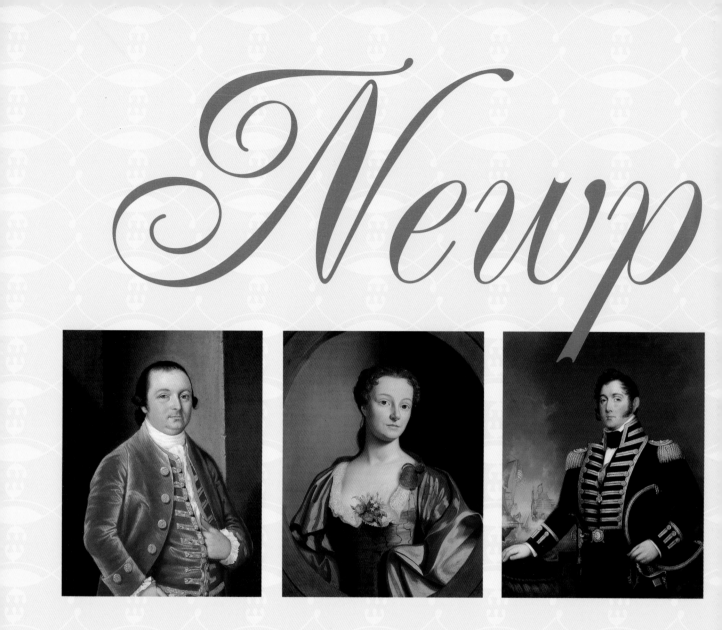

ortraits

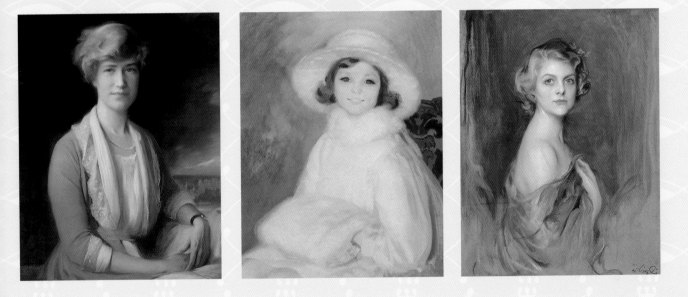

Newport Art Museum

University Press of New England · HANOVER AND LONDON

University Press of New England, Hanover, NH 03755

© 2000 by Newport Art Museum

All rights reserved

Printed in Singapore

5 4 3 2 1

CIP data appear at the end of the book

Contents

Director's Foreword

*A*LTHOUGH WE OFTEN hear it is *location, location, location*, most of us would respond by saying it is also *people, people, people*. Happily, in Newport, Rhode Island, a splendid location has always drawn extraordinary people. From the beginning of European settlement, Newport's fortune was ensured by an extraordinary harbor that encouraged commerce and by colonists who welcomed religious differences. These resulted in opportunities for men and women of ambition, vision, and ability to thrive. As they prospered, they founded and supported educational, cultural, and commercial institutions as well as businesses that bespoke of their acumen and their enlightened interests.

As Newport's history was made during the New Republic and on into the nineteenth century, her first families welcomed relatives and other newcomers, all of whom added to the community's richness. As the century progressed, Newport, now admired as a summer resort, attracted a distinguished group of "summer people" who did much to establish the outside world's perception of the city today. From New York, Boston, and Providence, as well as from farther away, families came every summer; initially residing in hotels and then often building summer homes, they changed their status from "summer visitors" to "summer residents."

The Gilded Age brought to Newport the new industrial elite, and their parties and sporting events, as well as their often palacelike residences, added to the city's image as a resort for wealthy society leaders. Some were here for a few weeks in the summer, and others stayed longer; all left their marks on this city by the sea.

In the twentieth century, Newport, taking its place internationally, has drawn visitors and residents from all over the world and a variety of backgrounds. Its residents are individuals of achievement and distinction with varied interests: social, philanthropic, business, cultural, and sporting.

When one talks about Newport, one must celebrate its people. Therefore, in 1992, the Newport Art Museum honored Newport's people by presenting them as they chose to present themselves—in portraits. Through the extraordinary efforts of two museum trustees, Elizabeth Brooke Blake and Edward L. Stone, a show of nearly two hundred portraits was brought together with the assistance of then–Museum Director Cora Lee Gibbs. The exhibition filled the museum's two buildings and brought to the public more than a hundred and fifty works that are owned by the sitters or their descendants and thus are rarely or never in the public arena. This exhibition, appropriately named *Newportraits*, was the basis for this book. Together, they celebrate this community by presenting images of its people and, through this volume's essay and catalogue, their stories. As Eileen Warburton writes so eloquently in her essay, "it was when all these portraits were exhibited *together* that the contextual life of the city—its heady commerce, its vivacious fashionableness, its sophisticated patronage, and its profound interconnectedness through the generations—was dramatically visible."

Yet this volume is about more than Newport. It is also the story of America's interest in portraiture and a catalogue that includes the work of many of its most significant portrait artists, including Robert Feke, Joseph Blackburn, Gilbert Stuart, G. P. A. Healy, Hiram Powers, John Singer Sargent, Howard Gardiner Cushing, Daniel P. Huntington, John Quincy Adams Ward, John La Farge, Thomas Nast, Larry Rivers, James Rosati, Andy Warhol, and Richard Lindner. Because the Newporters who commissioned portraits were also citizens of the world, some Newporters included here were painted by artists from Britain, France, Italy, Estonia, Russia, Spain, The Netherlands, Norway, and Mexico.

The Newport Art Museum was able to bring together these notable works of art in the *Newportraits* exhibition and this volume only through the generosity of our many lenders. The catalogue section of this book records the names of these individuals and institutions; it is our pleasure here to thank them for their generosity and for their patience as we brought this publication to completion.

The Newport Art Museum also gratefully acknowledges the contributions to this book of Eileen Warburton, historian and essayist, and Cora Lee Gibbs, art historian and cataloguer. Their work in *Newportraits* leads us to an increased understanding of Newport and the role its residents have played in American patronage and social history, as well as in the history of portraiture. We are grateful to Cathy Carver who took all the photographs in this book. We also are indebted to the many colleagues who helped us verify spelling, dates, names, and other

details and to other colleagues for their support. These individuals include Arnold Cogswell, Tom Leavitt, Mark Simmons, and Richard West. It is also important that we acknowledge our friends at the University Press of New England, first for their enthusiasm over this project then for their patience as we prepared the manuscript. I want to express my special appreciation to Newport Art Museum trustee Clarkson Potter for his personal support throughout this project. Ms. Warburton wishes to acknowledge the following individuals for their help with her research: Alletta Morris Cooper, Fred Cushing, Noreen Drexel, Jemison Faust, Bertram Lippincott III, Nuala Pell, Pyrma Pell, Elizabeth Prince de Ramel, Countess Anthony Szápáry, and John Winslow. Cora Lee Gibbs has asked us to thank Jeanine Hamilton and Anne Moore. Although the museum endeavored to achieve accuracy in this volume, we apologize in advance for any errors found herein.

We are deeply appreciative of the substantial support for this publication received from the Alletta Morris McBean Charitable Trust, the Rhode Island Committee on the Humanities, and the late Mrs. Carolyn Skelly. The museum shares their belief that the future is more secure when informed by the past.

Finally, for the trustees and staff of the Newport Art Museum, I wish again to acknowledge and thank Elizabeth Brooke Blake and Edward L. Stone for their terrific idea—*Newportraits*, which they made happen with great style, enviable quality, and excitement—and for their patience as we made this volume a reality. We dedicate this book to them, for their dedication, knowledge, persistence, and insight made this project a reality.

Judith Sobol, Past Director
Newport Art Museum

Newportraits

Newportraits: A Retrospective

EILEEN WARBURTON

*N*EWPORT, RHODE ISLAND, began sitting for its portrait just about a century after the city's founding and has continued to offer its collective face to the world ever since. The first Newport portraits in this collection have a kind of engaging awkwardness. Merchant seamen sit stolidly, their plain, solemn faces perched disproportionately on stiffly posed conventional bodies, all supplied by a traveling limner. By contrast, some of the most recent portraits are highly distinctive projections of the postmodern international culture—an elegant, emerald-decked woman in a surreal landscape, a miniskirted Bohemian girl assembled against vivid blocks of pigment, and our most fashionable First Lady (see cat. 129) silk-screened in multiple effigies. Divided by historical era, occupation, and probably philosophy, these sitters have in common a place and an attitude.

The shared landscape of these portrait people is Newport, a singularly lovely small city on the Atlantic coast of North America. The shared awareness is of making an image, projecting a representation of one's self as a valuable subject to view. As individual sitters, they were indeed self-conscious. But as citizens on view, they were unusually conscious that they were cultural leaders as well. This survey collection, which ranges from the colonial primitive to the most sophisticated, can chart the course of American painting and taste. Further, these portraits give face and feature to American history as it was lived in one representative American city. Here are portrait images that, when taken one by one, assert the personality and status of their individual subjects. When taken together, they reflect a complicated New World story, adventurous and proud out of all proportion to the size of the town where the subjects lived.

Among small cities in the United States, Newport, Rhode Island,

offers itself as a kind of historical exemplum, a place out of American legend. Carved out of the colonial coastal wilderness by religious rebels in 1639, the town became quickly notorious for its liberty of conscience and as quickly famous for its even bolder liberty of commerce. From its first generation of opinionated tradesmen-farmers, Newport both bred and welcomed those who seized the New World's opportunities for generating new ideas and new wealth. Thus was Newport's character cast as a distinctive image of mercantile fortune and cultural patronage, an image that would endure for three and a half centuries. The first settlers were succeeded by merchant adventurers, and those were followed by the architects of American industrial expansion. The heirs of these new plutocrats were people of substance and influence: diplomats, sportsmen and -women, social leaders, and patrons. All were shapers of cultural standards in the emerging experiment of the United States. In pursuit of lives that were expansive and rich, these Newporters cultivated the arts as avidly as they developed business.

It was two contemporary Newporters who conceived the notion of a Newport portrait show for the Newport Art Museum. In the fall of 1991, the museum's newly sharpened focus on local and regional art stimulated the imaginations of trustees Elizabeth Brooke Blake and Edward L. Stone. Surveying the artistic abundance immediately in front of them, the two recognized that within ten minutes of the Newport Art Museum there were "literally hundreds of portraits by astoundingly good painters." On closer examination, they realized that the choice of painters seemed to parallel what was going on in the community—from the traveling limners of the colonial period through the international standards of the Gilded Age and the twentieth century. As enthusiastic curators, Mrs. Blake and Mr. Stone found that "magical things began to happen" as they culled loans from friends and the institutions of the city. It was "a treasure hunt," says one—"an act of discovery," insists the other.[1] The several thousand visitors to the exhibition the following summer must have agreed, for it was when all these portraits were exhibited *together* that the contextual life of the city—its heady commerce, its vivacious fashionableness, its sophisticated patronage, and its profound interconnectedness through the generations—was dramatically visible.

Visitors to the exhibition were often heard to remark with pleasure that the arrangement of the gallery walls was "just like a family album." Like any family album, however, *Newportraits* is eloquent for only a portion of Newport's whole story. These self-confident faces represent a small group of families—the merchant and the ship's master but not the slave who was often the cargo or the countinghouse clerk; the elite industrialist of the Gilded Age and his lady of high society but

not the Irish housemaid or the Portuguese gardener; the diplomat or the soldier of the twentieth century but not the shopkeeper and the schoolteacher who lived across town. Nonetheless, our selection is a wonderfully important part of the whole story, for the highest ambitions and aspirations of a community are often reflected in the individual faces of just such a gathering of portraits. Such is especially true here, for the aspirations of this community were for grace, cosmopolitan culture, and sophisticated taste.

Newporters' aspirations also included the cultivation of the arts, and they were, individually and as a group, ambitious for Americans to take their place in the first ranks of the artists of the world. These Newporters were all patrons. Just as they were quick to seize opportunities for themselves, they were quick to adopt and promote talent. Both opportunity and promotion were abundant in the late colonial period, when portraiture in Newport began.

Scholars have often called the years between 1720 and the American Revolution Newport's "Golden Age." No longer the rough settlement of the century before, Newport had bloomed into one of the five great colonial cities of North America. By any standard, it was an extraordinary place. In addition to being blessed by the mild Gulf Stream climate and commercially friendly geography, Newport had a century earlier established a legal policy of freedom of thought and religious tolerance that was unique on the North American seaboard. As that rare community "where none bee accounted a delinquent for doctrine," the town received religious refugees from both the Old World and the New and welcomed Quakers, Jews, freethinkers, and lapsed Puritans as warmly as Baptists, Congregationalists, and Anglicans. A kind of benign acceptance reigned in regard to commercial practice as well, and it stimulated enterprise and risk in international trade, privateering, finance and credit, and local manufacturing. Indeed, from the 1720s until the Revolutionary War, it seemed that all sea roads led to Newport Harbor, where a vast merchant fleet of more than five hundred vessels rode the tides—exporting rum, iron, textiles, agricultural produce, horses, fine furniture, and candles and unloading molasses, sugar, indigo, slaves, lumber, and all manner of consumer goods, both plain and exotic, from all over the Atlantic world.

In such an open, commercially tolerant economy, Newport merchants and ship owners grew wealthy. Some, indeed, created fortunes and splendid lifestyles that rivaled those of any European aristocrat. This wealth brought with it new standards of taste, new pride in social position, and new patronage for the fine arts such as the emerging colonial societies had not experienced before. Thus, along with magnificent public and private architecture, superbly fashioned furniture, exquisite

silver- and pewterware, and sophisticated music, dance, and theatre, portraiture flourished in Newport. In emulation of European gentlemen and ladies, the most successful families commissioned portraits that would display their public faces and advertise their social achievement.

Colonial Newport was a place of astonishing opportunity. The town's finest society in this Golden Age was a heady combination of native inherited wealth and unstoppable newcomer talent. This very American combination is as evident in Newport at the turn of the twenty-first century as it was in the middle of the eighteenth. This sense of opportunity in an increasingly sophisticated environment must have attracted the earliest portraitists just as it brought other talented young men to the English colonies. So it was that Newport's first great intellectual and Newport's first great portrait painter arrived together. In 1729, artist John Smibert disembarked at Newport with his friend George Berkeley, who appears in our collection in a copy portrait done by Alfred C. Hart (cat. 21) around 1840 from Smibert's famous *Bermuda Group: George Berkeley and His Family* (1730, Yale University Art Gallery). Berkeley came out to the colonies full of Anglican Christian idealism, fired with the idea of founding a college in the Bermudas for the benefit of Native Americans and the children of slaves. In colonial days, Newport fortunes were intimately connected to plantations and trade in the Caribbean Sugar Islands, and the New England seaport was an eminently logical spot for Dean Berkeley and his family to settle for three years to await the promised funding for his enterprise. Alas for the envisioned college and the high hopes of the would-be founder, the money never materialized. But for Newport, Berkeley's sojourn was a turning point, for he was one of the great men of his age. The friend of Alexander Pope, Jonathan Swift, and George Handel, Berkeley was a theologian, Lockian philosopher, poet, writer, and patron of the arts. His presence was a catalyst to scholarship and philosophic inquiry among wealthy, educated Newport men. The Literary and Philosophical Society, which formed around him in 1730, led to the founding of The Company of the Redwood Library in 1747, years after Berkeley returned to Britain to become Bishop of Cloyne. Happily, another of his lasting contributions to Newport and the emerging colonies was simply delivering John Smibert, the painter, to America. Smibert painted prominent Newporters for a year before moving permanently to Boston. There, Smibert pursued a successful career as a portrait painter and helped to instruct and inspire such colonial-born talents as John Greenwood, John Singleton Copley, and Robert Feke.

Many of the earliest of the Newportraits reflect the opportunities

of wealth through Newport's international sea trade. Captain Philip Wilkinson (cat. 3), who immigrated from Ireland and married in Newport, appears in a Robert Feke portrait (about 1740); he poses at his writing table while one of his ships, under sunny skies and a fair wind, sails off to foreign ports. A few years later, the English-born painter Joseph Blackburn portrayed Captain John Brown (cat. 5) and Jane Lucas Brown (Mrs. John Brown) (cat. 6) of Newport (they may be distant relatives of the Providence Browns) in similar fashion. The iconography, such as the rose for Mrs. Brown's virtue and the book and writing implements for Captain Brown's learning and commercial position, indicates the sitters' character as well as their station in life. The costumes in all three portraits suggest comfortable income without ostentation, modest substance over fashionable display.

Mrs. Joseph Wanton (cat. 2, *Mary Winthrop Wanton* by Robert Feke, about 1740), in contrast, represents an old, landowning, merchant family so established that it dominated colonial politics. Young Mrs. Wanton's costume is so fashionable for the mid-eighteenth century that a hundred years later the cut of the bodice so scandalized the Redwood Library's Directors (to whom it had been given) that they insisted that artist Jane Stuart decorously tuck a modest nosegay of flowers into the offending bosom. Jane Stuart complied, protesting, however, that it was an act of vandalism.

Elizabeth Pelham Harrison's portrait (cat. 4, Joseph Blackburn, about 1754 or 1755) is a reminder of the collision between the expectations of established families and the ambitions of talented newcomers in a town like Newport. One of the town's great romantic legends tells how the beautiful heiress of the magnificent Pelhams eloped, over the objections of her family, with her true love, a penniless sea captain dependent on the charity of her relatives. But the young husband was the brilliant Peter Harrison, shortly to be a great commercial success and the innovative architect of Newport's finest colonial buildings. The love match endured, and new wealth soon matched old wealth.

Such portraits as those of the Banister family, Abraham Redwood, and Jacob Rodriguez Rivera reveal that this culture of opportunity still existed in Newport around the time of the Revolutionary War. The Banister portraits by nineteen-year-old Gilbert Stuart (who knew the family well) are a clear assertion of the status and social position of one of Newport's most important merchant families. John Banister (cat. 8), the son of a prominent international merchant, was himself a merchant with global contacts, a slaver, a privateer, and an investor. In his portrait, he appears, in his rich red coat, to be proudly aware of his worth. The portrait of his wife and child (cat. 9) hints of dynastic influence, as indeed was the case. Mrs. Banister was born into the

prominent merchant and chandlering Stelle family. The son, then about five years old, was their only child.

Nothing could be more persuasive of the truth of Newport's tolerance and opportunity than the observation that at the time of the Revolution the wealthiest, most socially visible men in the town were Quakers and Sephardic Jews. Elsewhere in the colonies, men of these sects were still regarded with suspicion and prejudice. In the seventeenth century, they would not even have been received. But colonial Newport, with tolerance its most cherished civic virtue, had made room for these outcasts as early as the late 1650s. So the portraits of Abraham Redwood (cat. 16) and Jacob Rodriguez Rivera (cat. 10) represent men of long-settled, prospering communities. The genial Redwood (cat. 16), who appears in Samuel King's portrait of him wearing his plain Quaker garb and appropriately holding a book, was one of the richest men in Newport. He was also, according to a contemporary observer, the greatest public and private benefactor of his time. He is evidence of Newport's intimate connections with the Caribbean Islands, for the foundation of his enormous wealth was his Antigua plantation. In 1747, he endowed the Collection of the Redwood Library, which bears his name, establishing this institution with friends and associates who had begun sharing their philosophical conversations years before in the days of George Berkeley.

Jacob Rodriguez Rivera (cat. 10), also painted by Gilbert Stuart just before the Revolution, was one of the great international merchants of the period. Among other ventures, he successfully established the spermaceti candlemaking industry in Newport. A Sephardic Jew with family connections in Portugal and on Curaçao, he helped found and build the synagogue and was a director of the library his friend Abraham Redwood founded. His financial house, built prominently on the parade (now Washington Square), has remained a bank to this day.

There is only a copy portrait of Reverend Ezra Stiles (cat. 15) in this collection. It represents him late in life, when he was President of Yale College. It is important, however, to connect him to 1755 to 1776, when he was the minister of the Second Congregational Church on Clarke Street and an indefatigable observer of Newport. Stiles was acquainted with everyone and was friends with most. The soul of tolerance himself, he was unfailingly curious about everything that crossed his vision. He studied astronomy and fruit cultivation, raised silkworms, became Librarian at Redwood Library, learned Hebrew from the rabbi at the synagogue, and kept a wonderful diary that records the daily life around him in gossipy, delightful detail.

The painters who recorded these characters were themselves examples of the hurly-burly opportunities of the Golden Age. Like John

Smibert, Joseph Blackburn came to the colonies to make his fortune and entered through the Caribbean ports. As a skilled painter of lace details and fine folds in fabric, Blackburn would have spent a lifetime in England as an assistant in the studio of some master. In America, he seized the opportunity to become a master himself. Robert Feke, a native-born painter, learned what he could from engravings of European work and from the work of traveling British painters. Samuel King, who painted the portrait of Abraham Redwood, had a dual local career; he painted both portraits and the decorations on musical instruments made by his family. The greatest portraitist of all of them was Gilbert Stuart, later to be called the "Father of American Portraiture." Born in 1755 over a Kingston, Rhode Island, snuff mill, Stuart grew up in Newport, where he picked up the beginnings of his art by studying with the British traveling painter Cosmo Alexander. It is arresting to realize that the early Stuart portraits—which document the merchant princes of Golden Age Newport, the John Banisters (cat. 8 & 9) and the Jacob Riveras (cat. 10)—are by the hand of a rough, young talent not yet twenty years old. Of all these portraits, perhaps the most affecting is that of Stuart's best friend, Benjamin Waterhouse (cat. 11), painted in England just after Waterhouse sailed to Europe to study medicine. Later, as Dr. Waterhouse, he would become a renowned Harvard professor and would be credited with introducing the smallpox vaccine to America. In Stuart's intimate youthful portrait, however, Waterhouse is imbued with his friend's affection.

These portraits freeze a golden moment before the Revolution scorched the age into oblivion. Within a year, these lives and the fate of the town had changed forever. Mary Winthrop Wanton's husband, the colonial governor, was removed from office by the Legislature for his Loyalist sympathies. Much of their property was confiscated, and several of their children fled to England. On the other side of the political fence, John Banister hazarded his fortune on the patriot side. His loyalties cost him his British business contacts, and he, too, was much the poorer for the Revolution. Elizabeth Pelham Harrison and her husband, Peter Harrison, were Loyalists who relocated to Connecticut. Like the majority of the Jewish congregation, Jacob Rodriguez Rivera escaped the city in the face of the British occupation. Even Gilbert Stuart, whose family had already fled to Nova Scotia, followed his friend Benjamin Waterhouse to England, where he remained for nearly twenty years. Ezra Stiles, strong for American liberty, records the anguish of hearing the British bombardment of Newport on December 6, 1776, from fifteen miles away. Soon Stiles, too, would leave for his new position at Yale. Newport's Golden Age, and its colonial portraiture, had ended.

The British occupation of Newport from 1776 to 1779 effectively destroyed the commercial hegemony of the town. By the time the French liberated Newport, the town's trading network and the mercantile wealth that had sustained it had dissolved. The only portrait in the collection from the Revolutionary War era depicts France's Marquise de Rochambeau (cat. 18), the wife of the commander of the French forces that aided the American rebels. It is of interest to our story only because she wears on her wrist a memorial miniature of George Washington.

Though suffering an economic collapse that forever destroyed its premier commercial role in American trade, Newport in the years after the Revolution still had its share of distinguished and achieving families. George Gibbs (cat. 13), painted in 1798 by the repatriated Gilbert Stuart, is one of the merchants whose success survived the war. Indeed, the grain-shipping partnership of Gibbs and Channing was so prosperous that at one point he and his brother-in-law, Walter Channing, owned seventy-five international sailing vessels. Contrasted with the earlier Banister family pictures, this portrait is startling evidence of how mature and classically trained Gilbert Stuart had become while in Britain. Now reestablished in the United States, Stuart was the premier portraitist of the generation of American Founding Fathers, including of course George Washington. Though the artist never lived in Newport again, his roots remained here. After his death, his family returned to Newport to live. Here his talented daughter Jane Stuart painted portraits and copies of her father's works (cat. 27 & 28) to support her mother and sisters.

Newport roots remained for others who had fled with the Revolution. The sons of Rabbi Isaac Touro, for example, established families and prosperous businesses in other parts of the country. Yet both Judah and Abraham generously remembered their birthplace and the synagogue in their wills: Abraham Touro left funds for the repair and future upkeep of the then-closed house of worship, and Judah Touro (cat. 10), whose portrait is in this collection, established the Judah Touro Ministerial Fund, which is still annually disbursed by the Newport City Council.

In the first half of the nineteenth century, as Newport recovered from the Revolution, its reputation revived. Newport became known as a community that contributed her finest young men to the U.S. Navy, as a town congenial to the arts, and as an increasingly fashionable summer spa.

Oliver Hazard Perry (cat. 28) and his stunning victory at Lake Erie in September 1813 are commemorated here in a posthumous portrait by Jane Stuart. By brilliant tactical maneuvers, Perry and his crew of

youthful Newporters defeated and captured the entire British fleet. He went on to carry out quasi-diplomatic assignments in South America. His younger brother, Matthew, is also justly celebrated for his naval missions in Africa and South America and for his opening of Japan to Western commerce in 1854. Oddly, Jane Stuart's portrait of the Little family (cat. 27) also presents a future great Newport naval strategist and innovator, although the artist was surely unaware of this during the sitting. The child holding out the rosary in this iconic painting is William McCarty Little, who, as an adult, created the war games concept at the United States Naval War College.

In addition to Jane Stuart, other painters continued to find Newport a congenial place to live and work. This collection includes the self-portrait of Michele Felice Corne (cat. 19), an Italian painter known for interior wall decorations and murals in public buildings. He lived a stone's throw from Stuart's house and studio. Charles Bird King's *Self Portrait at Seventy* (cat. 30) is also among the Newportraits. A fair portrait painter, King was a superior copyist, and the portrait collection he secured for the Redwood Library attests to his generous spirit, noted by all his contemporaries. John La Farge reveals his fine sense of Newport people in his mid-century pencil portraits of John Chandler Bancroft (cat. 113) and Thomas Sergeant Perry (cat. 114). Another important artist who was a resident for a time was William Morris Hunt, represented in this collection by his portrait of Wheaton Theodore King (cat. 34).

The portrait of the King lad, painted posthumously in the uniform in which the young Union officer died, has a special poignancy, of course. But children, overall, are more generously represented as this collection moves into the nineteenth and twentieth centuries; indeed, the young are presented in a new way. In an earlier time, children appeared as part of family portraits or individually in the intimacy of miniatures. In the early part of the nineteenth century, artists began to portray American children as though they were as important as adults. This may reflect the influence of the Romantic movement and the growing domestication of family life in the early Victorian period, a sentimentalization of children that increased their importance and visibility. About the same time, infant mortality rates began to drop, encouraging parental hopes for their children's survival and security. Altogether, these very typical portraits present a general sense of expectation and promise in the children. Promise, of course, can mean the warmly sentimental presentation of *The Grosvenor Boys* (cat. 26) by James Sullivan Lincoln or the highly formal, classical presentation used by Charles Ingham for *Eliza Mier Lorillard* (Bailey) (cat. 103) and by G. P. A. Healy for *Richard Washington Corbin As a Young Man*

(cat. 24) and *The Wetmore Boys* (cat. 25)—all portraits that refer to a traditional aristocratic iconography. These children are one measure of what was happening in portraiture generally. As the new democracy supplanted the old colonial standards during the nineteenth century, the tradition of the public portrait grew a new popularity for an intimate or domestic portrait, often less formal than its predecessor.

Newport had been a summer resort from pre-Revolutionary days. In that cultural heyday, planter families from the Carolinas and other southern ports had sailed north along the Gulf Stream to spend the malaria season in the salubrious climate of sophisticated colonial Newport. After the collapse of the booming prewar economy, this dependable summer trade returned, becoming one of the enduring legacies of the Golden Age. In addition to its cultivated traditions and blessed summer weather, Newport was fortunate in its proximity to the country's first burgeoning commercial and financial centers in Boston, Philadelphia, and, most of all, New York. As these cities prospered and their social elites emerged, Newport grew alongside them as the premier summer resort of America.

An indigenous American High Society began to flourish in the three generations following the founding of the Republic. Like a polished mirror, Newport—a favored gathering place—reflects this image. This aristocracy anointed Newport its Queen of Resorts, while Newport, in grateful turn, crowned its ambitions and set the seal upon the social arrival of each aspiring family. Like the colonial society that preceded it, the new American High Society, reflected in our nineteenth-century mirror of *Newportraits*, was a New World amalgam of thriving traditional families and commercially vigorous new ones.

Some socially prominent families, indeed, had the sort of landed gentry antecedents associated with European aristocracy. The Englishman Thomas Pell, for instance, was deeded his Hudson River estate, Pelham Manor, in 1687. The Morrises were another English manorial family from the same era (deed of estate, 1697) and would later include a signer of the Declaration of Independence. In Philadelphia, families that would later appear in Newport—including the Ingersolls, Whartons, and Biddles—played prominent roles in the Revolutionary fervor of the 1770s as signers of the Non-Importation Resolution in defiance of the Stamp Act of 1765. Stalwart Newport sojourners also descend from the earliest arrivals to Massachusetts. Newport's knowledgeable twentieth-century social leader John Winslow is descended from some of the courageous 1620 colonists of the *Mayflower*, the first vessel to the Massachusetts Bay settlement. Fishes and Wetmores arrived in 1635 aboard the appropriately named *Increase*, the third passenger vessel to that New World, while such families as the Warrens and Auchin-

closses appeared in the colony almost as early and remained equally dedicated to the common good.

Only a few years past the Revolution, however, the great American fortunes were those founded in trade, and these earliest aristocratic families would continue their good fortune through marriages or business alliances with new mercantile money. In the young Federal nation at the turn of the nineteenth century, the prosperous families were those in trade. Among the New York families who would later be prominent Newport Summer Colonists, the Goelets began as hardworking ironmongers. The Rhinelanders expanded from baking to refining sugar. The Barclays were brewers; the Schermerhorns, ship chandlers; and the Astors, fur traders. The rising tide that lifted the boats of all these families was Manhattan real estate. They and many other New York merchant families had invested in the little-developed land north of the city. The opening of the Erie Canal in 1825 determined the future of New York City as the great market of the New World and of New Yorkers as the twenty-one-carat foundation of New World Society. The career of Jacob Lorillard is a good example of the rise of this generation. A lad without means barely out of childhood at the time of the Revolution, Lorillard was apprenticed to a tobacconist. As a young man, he went into business for himself with a thousand dollars in capital borrowed from his brothers and built an empire in cigars and snuff. Lorillard worked to educate himself in languages and literature, even as he invested his profits shrewdly in real estate to better his financial position. At his death in 1843 at age eighty, the newspapers, searching for the right expression to describe a man of his affluence and position, coined a useful new word, "millionaire." Through the Lorillard children—four daughters and a son—the family became allied by marriage to a host of socially prominent New York families. For example, Eliza Mier Lorillard (cat. 103), whose girlish portrait is in this collection, became Bailey upon her marriage, and her sister Emily married a Morris. The first-cousin children of these unions married one another and produced a line that led to the Baileys, Smiths, and Morrises seen in these Newportraits. Another Lorillard sister's child married into the Pell family, and another's descendants were Spencers. Most of these descendants, including those still bearing the Lorillard name, were Newport summer residents at one time or another.

Beyond New York, many fortunes were built on the foundation of international trade rather than real estate. At the turn of the nineteenth century, the founders of families who would later be among the most elite of the leisured class were forging their daring way in a world of high risk and great opportunity. The Browns of Providence, the Careys and Cushings of Boston, and the Kings and Wetmores of

Newport, for example, were all prominent international shipping merchants who were active in the China Trade as well as in commerce with the European nations, which were sparring with Napoleon or with one another.

This trade with China was fraught with risks, although the rewards could be great. The founder of the Cushing fortune, for instance, was an orphaned Perkins grandson who lived a colorful life as the shrewdest China Trader in a ruthless business. Sent to China in 1802 at age sixteen, virtually unaccompanied, Cushing developed into a legendary merchant who for twenty-six years negotiated goods and cash specie in and out of the Canton Co-hong factories, a feat that even included running blockades during wartime. When Cushing eventually returned to Boston, he found American life almost intolerably uncivilized in contrast to life in China. He found solace by marrying one of the artistic Gardiners and setting up a Beacon Hill house staffed with Chinese servants and incorporating many elements of Chinese decorative design. The Cushings who followed were deeply interested in the fine arts in America, so perhaps these events set a tradition. Likewise the Browns—originally colonial merchants in molasses, slaves, and other commodities of the era—transferred the concerns of the family business to this newly opening Asian market in the late 1780s. From 1787, when *The George Washington* set sail for Canton, to 1838, when the Browns sold their last vessel and invested all in the textile industry ashore, the family fortune rode on the waves to the Far East.

Philadelphia's first families of the period distinguished themselves in investment banking as the country's banking industry was born. Growth in this industry reflected the growth of the United States and provided new opportunities for wealth. For example, a portrait painter from the Tyrol, Francis Martin Drexel arrived in this country in 1817 and made a living as an itinerant portrait painter, even touring through Mexico and South America. Remarkably, upon settling in Philadelphia in 1831, this artist discovered in himself an extraordinary talent as a wildcat financier. His son, Anthony J. Drexel, carried on the business his father began and became one of the great bankers of an age of national commercial expansion.

These rising Society families discovered the Newport that Southerners had known from colonial days, and by the decade preceding the Civil War, many were regularly in residence for the inviting summer weather of each season. Included in this collection, the Pells, the Kings, the Wetmores, the Wards, the Grosvenors, the Joneses, and the Browns were all pioneer summer colonists from the 1840s. The Newport they visited was a rustic provincial village, down-at-heel in a charmingly nostalgic way. Here, well-to-do families would happily forego the so-

phisticated city pleasures of New York, Providence, or Boston to enjoy leisurely country holidays far from any social or commercial competition. Most summer visitors stayed in one of the great rambling hotels that occupied the crest of the hill along unextended Bel Vue Street. From early in the 1840s, however, families such as these began building summer cottages in the immediate hilltop neighborhood. Their dependable presence led to a wave of land development along the Atlantic Ocean coastline, most notably the opening of the Ochre Point section, the extension of renamed Bellevue Avenue in 1850, and the creation of the Ocean Drive just after the Civil War.

The portraits of these earliest summer colonists bespeak a world of solid values and quiet gentility. *Dr. William Grosvenor* (cat. 31) by G. P. A. Healy depicts an upper-middle-class professional physician and gentleman. The portraits of John Carter Brown (cat. 48) and his wife, Sophia Augusta Brown (cat. 50), dramatize the kind of established social position that eschewed ostentation. These Browns were steady, dedicated benefactors of learning in the United States. The portrait of John Carter Brown (cat. 48), the patriarch of the family, is by an unknown artist. Appropriately for the founder of the John Carter Brown Library and major donor to the Redwood Library, Brown is shown in a traditional portrait of relaxed formality surrounded by the books of his personal library. Marking his place with his finger, Brown seems to be lost in thought about his reading. This moment of reflection seems shared by his widow, Sophia Augusta Brown. In her portrait by Leon Bonnat, she has an appealing warmth and intelligence that reflects depth rather than grandeur. Their daughter, Sophia Augusta (cat. 51) (painted by François Fleming), married their widowed neighbor William Watts Sherman (cat. 53, painted by Theobald Chartran); the two Sherman daughters, Irene and Mildred (cat. 54), posed charmingly as girls against an Ocean Drive background in Chartran's 1901 portrait, thus descended from the Browns. The daughter of Irene Sherman Gillespie (cat. 57, painted by Fleming in 1901), Eileen Gillespie became Mrs. John Slocum, and her first cousin Noreen, one of the daughters of Mildred Sherman Stonor (cat. 56), Lady Camoys (also painted by Fleming in the same year), married John R. Drexel III. So the portraits of the Brown family group in our collection include many latter-day Browns, along with many Shermans, Slocums, and Drexels. To enrich the Brown connection to Newport, the John Carter Browns were the first cousins of the Ives children. By marriage, these became the ancestors of the Goddards and Gammells, still loyally associated with the Newport summer colony and depicted in this portrait collection.

Both the Jones and the Ward families were the kind of decorous and genteel New York clans who brought taste and quiet cultivation to

Newport on their annual pilgrimage. Their presence is indicated in this collection by two of their most distinguished children. But who, examining these fashionably lush images of sumptuous fabrics, demure eyes and hands, and restrained postures, would guess that Maud Howe (cat. 1, in a portrait by Benjamin Curtis Porter) and Edith Jones (cat. 36, in a portrait by Edward May) were both destined—as Maud Howe Elliott and Edith Wharton—for fame as writers, indeed that each would win the Pulitzer Prize?

Another antebellum family to make Newport their summer home was the Cushing family. Robert Thomas Cushing, son of the family founder, built his house overlooking the Atlantic Ocean in 1860 and brought to Newport a family with an ongoing commitment to the fine arts in America. Cushing's daughter, Mary Louisa (cat. 71, 72, 73), married the painter Edward Darley Boit, lived the life of an expatriot among artists in France and Italy, and raised four daughters (one of whom herself became a painter). Frequently a model to their artist associates, Mary Louisa is the subject of no fewer than three works in *Newportraits*, including the enormously appealing 1893 portrait by family friend John Singer Sargent. The friendship between Mrs. Boit and this painter, easily the leading Boston society portraitist of his day, is vividly realized in the straightforward geniality and honesty so apparent in this picture. Robert Thomas Cushing's grandson, Howard Gardiner Cushing, would become a distinguished painter whose work also appears in this collection.

The years after the Civil War brought changes to American Society and thus to Newport. There was a new kind of wealth created by the enormous industrial expansion of the United States, stimulated by the war itself, the settlement of the western lands, the great waves of European immigration, and the development of transcontinental transportation systems. Whereas in 1843 newspapers had to invent the word "millionaire" in order to write J. P. Lorillard's obituary, by the 1880s there were among the new men industrialists and tycoons worth many millions of dollars.

The postwar era would have been, in any case, a time of heightened national self-awareness and of increasing grandeur on the international scene. However, this massive infusion of new wealth into society helped fuel a splendid blaze of public display and competition. The rising families felt compelled to spend lavishly in a manner that would cement their social positions and ensure their acceptance by established Society. Social satirist and novelist Mark Twain was to christen this era of flamboyant wealth the "Gilded Age."

As in earlier times of financial opportunity, a key problem for a class aspiring to culture, influence, and decorum was how to merge the

cultivated old families with the raw, new-moneyed people. In this Gilded Age of the late nineteenth century, Society's arbiter was Mrs. Astor, Caroline Schermerhorn Astor (cat. 32). Like the monarch of a uniquely American aristocracy, Mrs. Astor reigned over an exclusive circle whose worth was determined by family connection and professional respectability, all hinging upon recognition by this illustrious lady. For Mrs. Astor and Ward McAllister, who acted as something of a prime minister, the cautious intermixing of what McAllister termed the "nobs" (the established old families) with the "swells" (the fashionable newly rich) was a serious responsibility. The portrait in this collection depicts Mrs. Astor in her youth. In later portraits (not in this collection), Mrs. Astor appears regal and majestic. Quite as much as her celebrated diamonds and elegant gowns, these later paintings were part of the exalted public image of Society's leader that Mrs. Astor created and projected.

To the ascending families, social acceptance in Newport was critical to being fully initiated into the nation's most elite. As one insider would put it:

> Every summer [we] went to Newport like everyone else in our world, for in those days so much prestige was attached to spending July and August at the most exclusive resort in America that to have neglected to do so would have exposed a definite gap in one's social armour. It was an accepted fact that only those whose position in society was unstable never went there. Let them vaunt the charm of a country holiday, of a summer spent in Europe as much as they would, they deceived no one. Their acquaintances knew that they stayed away because they were afraid. For Newport was the very Holy of Holies, the playground of the great ones of the earth from which all intruders were ruthlessly excluded by a set of cast-iron rules.[2]

From the 1880s, when Mrs. Astor began to summer regularly in Newport, the aspiring families made Newport their seasonal social capital. Grandest among them were the Vanderbilts. This extensive, talented family, which came to dominate the summer scene in Newport as well as in New York, was founded by Commodore Cornelius Vanderbilt. In the manner of American rags-to-riches tales, the Commodore made his start at age sixteen (in 1810) ferrying passengers between Staten Island and New York City. Forty years later, he had built a vast fortune in steamships. In 1863, in the middle of the Civil War, he shrewdly sold his entire fleet and built a second, greater fortune in railroads.

With their new industrial-age millions, the Vanderbilts personified the rising class McAllister had called the "swells." Indeed, it was not until the family's third generation, in the early 1880s, that New York Society could be prevailed upon to accept the Vanderbilts into the narrowest, most elite circles of what had come to be called "The Four Hundred." So, it might appear this grandest of Gilded Age families came late to Newport. Yet this clan, quite as much as in such old resort families as the Browns and the Pells, had deep Rhode Island connections. On the side of Mrs. Cornelius Vanderbilt II, Alice Claypoole Gwynne Vanderbilt, the family traced its heritage back through colonial Newport merchants, including Henry Collins and Ebenezer Flagg, to Rhode Island governors, such as Richard Ward and Samuel Ward, and to no less than the founder of the Colony himself, Roger Williams. In the Gilded Age Vanderbilts, as with these other Summer Colony families, the Newport formula of old American pedigree matched to modern aspirations was visibly successful.

For the third generation—that of Cornelius Vanderbilt II, whose portraits by Daniel P. Huntington (cat. 82) and Benjamin Curtis Porter (cat. 83) appear in this collection—social accomplishment was registered in patronage of and interest in the arts quite as much as in his control of the New York Central Railroad. An avid collector of paintings himself, Vanderbilt was a founder of the Metropolitan Museum of Art.

The evolving sense of public self-consciousness among the leisured class is reflected in the nineteenth-century portraits in this collection. Around mid-century, Newport summer cottagers were content to build houses that architecturally echoed American antecedents and their materials. In their portraits, such as *Dr. William Grosvenor* (cat. 31) by G. P. A. Healy, and *Thomas Sergeant Perry Talking to Bancroft at Paradise Farm* (cat. 114) and *John Chandler Bancroft* (cat. 113), by John La Farge, there is a similarly straightforward American quality. But from the 1880s on, a new cosmopolitan elegance is in evidence. The generation of the Gilded Age looked to the grandest traditions of Europe for inspiration. Baronial summer palaces, modeled on the most splendidly aristocratic of Italian and French domiciles, were built along Bellevue Avenue. Continental formality and custom were introduced into upper-class daily life. The Grand Tour of Europe became *de rigueur* and formal portraits painted by European masters became part of social expectations. The young Edith Jones (later Wharton) was painted in England in all the opulence of red velvet in 1881 by English artist Edward May (cat. 36). French painter Leon Bonnat captured the self-possessed presence of New York real estate millionaire Ogden Goelet (cat. 43). Even five-year-old Gertrude Vanderbilt received the European master treatment in the refined formal portrait (1880) by Spaniard

Raimundo de Madrazo y Garreta (cat. 86). Of these Gilded Age state-
ments in the collection, the most dramatic is the lifesize image of Eliz-
abeth Drexel Lehr (Mrs. Harry) (cat 46) painted by Giovanni Boldini
in the early years of this century. The exquisite Mrs. Lehr is caught in
vivacious motion—the swing of her dress is arrested still rustling, and
the little dog, frozen for all time in a wriggle of escape. Mrs. Lehr her-
self described this celebrated Italian painter as a lovable creature in
spite of his many eccentricities, a true Bohemian, childlike in his crav-
ing for praise.[3] In a sadly cautionary way, this lovely woman represents
all that is brightest and all that is darkest in a Gilded Age fairy tale mar-
riage. Widowed by her beloved first husband, the sheltered Elizabeth
was wooed for her fortune by the manipulative Society trendsetter
Harry Lehr. This loveless match, which she endured without public
complaint for twenty-six years, ended in a second widowhood. She ul-
timately found happiness as an English aristocrat in her 1936 marriage
to the fifth Baron Decies.

In this international world of public image and wealth, the mem-
bers of the great families of the Gilded Age emerged as national figures,
even celebrities. Some of this is apparent in the drypoint etchings by
French artist Paul-César Helleu of sisters Gladys Moore Vanderbilt
(cat. 91) and Gertrude Vanderbilt (cat. 90) and their cousin Consuelo
(cat. 92), later Duchess of Marlborough, and in his charcoal portrait of
Charlotte Warren (cat. 115). Where a generation or two earlier, an eligi-
ble daughter of this class would have been protected, even somewhat
sequestered until her marriage, by the 1890s such fashionable young
women were highly publicized. They were, in fact, celebrated as a
superior American *product*, homegrown creations of feminine grace
and beauty, confidence and intelligence, and wealth and fashion that
could best anything the Continent had to offer. Helleu consciously
worked to display what one of his reviewers called his theme, "The
Grace of Woman, whereby his models are *discovered* in poses of charm-
ing intimacy."[4]

Public images take a different, private turn in the clubby cartoon
caricatures and informal portraits of Newport Society gentlemen. Part
of the appeal of a resort colony in the nineteenth and early twentieth
centuries to celebrated people increasingly scrutinized by the public
eye was the sense of relief and privacy possible in an enclosed, exclu-
sive world. Summer Colonists established exclusive domains through
a network of membership clubs for golf, sea bathing, reading, din-
ing, shooting, polo, and tennis. The earliest of these was the Newport
Reading Room (1854), a comfortable spot—chartered by a Wetmore, a
Lawrence, and a King—reserved for men alone. The tone for cartoon
portraits here was set by Thomas Nast (cat. 143), the famed political

cartoonist who became the first to influence public opinion by caricature when he waged a one-man publicity campaign against the Boss Tweed ring in New York. Indeed, Nast was responsible for the Democratic donkey and the Republican elephant. His cartoon self-portrait with his overdue bar bill is delightfully satirical and sets the tone of humor, mockery, and exaggeration that carries through Drian's Gilded Age cartoons and on into the examples from the 1920s and 1930s. Drian's sly sketches depict such local bon vivants as the genial Max Agassiz (cat. 139), whose Harvard professor father came to Newport to study microscopic sea life; the artist John Boit (cat. 142); and such gentlemen as Center Hitchcock (cat. 140) and Prescott Lawrence (cat. 141), both founders in 1897 of the Clambake Club, whose waggish device of a lobster rampant and the motto *Ex litore clamavi* proclaimed it a fun-loving league suited to a resort environment. An appreciation of the "gentleman's life" suffuses Spy's portrait of Alfred Gwynne Vanderbilt (cat. 99), depicted as a coaching whip. (Vanderbilt was the master of the celebrated coach Venture.) A similar perception of club members' characters continues in twentieth-century club portraits, from the crisp Edward Newton profile of Reginald Rives (cat. 148), president of the Coaching Club of America, to the amusing rendering of safari attire–clad Russell Aitken (a far cry from the head by Marshall M. Fredericks from the same period), to the easy-going semblance of Barclay Douglas (cat. 144) by Dugo, to the composed summery portrait of Henry Phelps (cat. 146) by William Prescott.

Among Newport clubs, the greatest of Society meccas was the Casino. James Gordon Bennett Jr. developed this new notion of a grand Society gathering place with ample provision for the new sport of lawn tennis, as well as for promenades, concerts, dancing, cards, shops, and refreshment. Legend has it that Bennett had instigated a practical joke at the Reading Room that earned him the censure of its Board of Governors. Incensed at this wrist slap, Bennet engaged the newly organized architectural firm of McKim, Mead, & White to upstage the stuffy Reading Room Governors with a radical new design in social assembly rooms. The Casino, which welcomed ladies as well as gentlemen, was the result. Bennett (cat. 156), depicted here in an oil portrait by Julian Story, was a champion sportsman, a yachtsman, a dashing whip, and the pioneer of polo in Newport.

Other society gathering places were created in the mid-1890s, two of the most important to the Summer Colony being the Spouting Rock Beach Association (1896) at Bailey's Beach and the Newport Golf Club (today Newport Country Club; 1893). Several names of Newport's sporting set appear over and over in the proceedings of the founding of these organizations—Vanderbilt, Goelet, Astor, Winthrop, Gammell,

Wetmore, Brooks, Spencer, Oelrichs, Wharton, Burden, Berwind, Belmont, Hitchcock, Taylor, Lorillard—an abbreviated but impressive Social Register. But in each endeavor the move was initiated and led by Theodore A. Havemeyer. Havemeyer, whose immense fortune was in sugar refining, actually introduced golf to Newport and was the first President of the U.S. Golf Association. While there is, unfortunately, no portrait of Theodore Havemeyer in this collection, his sporting family is represented by the 1912 Adolf Müller-Ury oil of his younger son, Frederick C. Havemeyer (cat. 45).

Portraits such as this formal image of Havemeyer or Boldini's *Elizabeth Drexel (Mrs. Harry Lehr)*, and such compelling scenes as Cushing's *Mrs. Cushing and Her Sister Ann (The Blue Porch)* (cat. 78) and Lynwood Palmer's *Sundown, Portrait of Mr. Rhodes in His Carriage* (cat. 147)—that smartly rendered Casino coaching profile with its high-stepping horse—document how the grace and elegance of resort life continued at Newport into the new century. But change was on the way. Although the portraits of Lieutenant Colonel and Mrs. Cortlandt Parker (cat. 164 & 165) by Ellen Emmet Rand and of Snowden Andrews Fahnestock (cat. 163) by Douglas Chandor date from the early 1930s, these handsome men in World War I uniforms are reminders that in 1917 this Newport society of leisured refinement would be tested by war. Indeed, there was a distinct chill from the very outbreak of European hostilities in 1914, for many Newporters had sons and nephews fighting in France from the earliest days of the war. In 1915, the Summer Colony was shaken by the death of Alfred Gwynne Vanderbilt. He was traveling on the ill-fated *Lusitania* when it was attacked by a German U-boat and gallantly surrendered his life jacket to a woman passenger. In the waning days of U.S. peace, one of the last magical social events was the dedication of the Blue Garden of Mrs. Arthur Curtiss James at Beacon Hill. In Mira Edgerly's delicate ivory triptych, Mrs. James (cat. 187) and the turquoise pools and azure delphiniums of her formal fantasy garden are remembered. In the first year of America's entry into the war, her husband, Arthur Curtiss James (cat. 155), was painted by Herbert Vos in his uniform as Commodore of the New York Yacht Club and owner of the famed yacht *Aloha*. Local families earnestly labored to support the war effort when the dreaded day came. For example, Hugh D. Auchincloss II (Hughdie) (cat. 151), also painted by Vos, invited the U.S. Navy to quarter naval submarine scouts at Hammersmith Farm.

The collection of Newportraits documents how the elegant customs of resort life, which resumed after the war, were interpreted with a timely modern flair. European and European-trained portraitists, such as Hubert Vos, were once more favored, for the Newport summer

community remained an integral part of an international cultural scene. Cathleen Vanderbilt's informal charcoal and crayon portrait by Olive Snell (cat. 100) is the epitome of the modern flapper mode of the 1920s, but other ladies appear in more traditional garb and presentation. Although the colors and brushstroke of English artist Simon Elwes's formal oil of Mrs. Bruguiere (cat. 181) strike us as almost contemporary, the pose of the gowned lady on the yellow sofa, with the draped yellow curtain behind her, is as aristocratically traditional as any Continental portrait from a century earlier. Alfred Hoen's appealingly feminine 1922 pastel of Alletta Nathalie Bailey Morris (cat. 106) shows this lovely mature woman in the softness of her favorite green dress. Elegant Cynthia Cary (Mrs. Guy Fairfax Cary) (cat. 182) is depicted in 1927 by English artist C. Edmond Brock; she sits backlit against red velvet drapery, and her long rope of pearls and fashionable dress offer a modern interpretation of a long-standing traditional presentation.

The taste for international portraiture would continue through the century with, for example, society painters such as Lucas Guaneri painting formal portraits of both Mr. and Mrs. James Van Alen III (cat. 157 & 158), French painter René Bouché creating elegant portraits of Noreen Stonor Drexel (cat. 167) and her daughter Pamela Drexel Walker (cat. 163), and distinguished French sculptor Gaston Lachaise modeling a fine bronze head of Katherine U. Warren. No less than Sir Alfred J. Munnings himself, President of the British Royal Academy, painted the wonderfully mobile equestrian portrait in profile of Frederick Henry Prince (cat. 149) at the hunt with dogs; the cloud-piled sky and landscape proclaim that it could be nowhere but England. Like Hubert Vos, some European artists ultimately came to reside in Newport themselves. The Russian-born Elizabeth Shoumatoff, for example, was a sharp-eyed watercolorist who could capture the essence of character in a face. She was a presidential portrait painter, but Newport became her true home. The large number of family portraits done in her typical watercolor on board from the 1930s into the 1960s attest to Shoumatoff's great local popularity. In this collection alone, she is represented by *Alletta Morris McBean (Mrs. Peter McBean)* (cat. 112) (about 1936), *Howard Gardiner Cushing Jr.* (cat. 79) and *Mary Cushing* (cat. 80) (1939), *Minnie Cushing* (cat. 81) (1960), *Nicholas Brown* (cat. 68) (1950), *Diane Vernes Brown (Mrs. Nicholas Brown)* (cat. 69) (1957), *John Nicholas Brown* (cat. 66) (1950), and *Anne Seddon Kinsolving Brown (Mrs. John Nicholas Brown)* (cat. 67) (1961). For his very bold and proud formal presentations, Norwegian Bjorn Egeli was also much sought after by those of the Newport resort colony who developed Washington, D.C., connections after World War II. The portrait of Ruth

Buchanan (Mrs. Wiley T. Buchanan Jr.) is an excellent example. Mrs. Buchanan's husband was President Eisenhower's chief of protocol. In this very formal oil, she is presented against the traditional curtained background in an arresting palette of lavender and bright scarlet. Several of Egeli's paintings of well-known Newport figures show them, boldly aristocratic, clothed in pink coat for the hunt, as in *E. Taylor Chewning Jr.* (cat. 153) (1952) and *William Wood-Prince* (cat. 152) (1969).

Homegrown artistic endeavor also began to make its way into Newport's art of the twentieth century. As the aspiring families of the 1870s and 1880s had become the established and influential national leaders of the next century, some of their interest in the arts passed from the acquisitive to the creative. The industrialists of the late nineteenth and early twentieth centuries acquired European art and drew inspiration for their imposing houses from grand European models because, up until their own era, these were the traditional symbols of elegance, power, and taste. American plutocrats assumed the mantel of these traditional symbols to signal their legitimacy and status to their peers, both nationally and internationally. Connected to this in many cases was a sense of patriotic responsibility, a kind of New World noblesse oblige, for building up respected American cultural institutions along recognizably traditional lines. Hence, major benefactors like Cornelius Vanderbilt II established or endowed museums, art galleries, operas, and universities. Likewise, their personal collections of acquired masterpieces (generally historic works of European making) formed the backbones of the collections of these new art museums. Thus the tastes the of newly educated American populace were formed through exposure to the cultural icons gathered by their wealthy countrymen.

Paramount among those educated to aesthetic considerations by exposure to these artistic standards were the children and grandchildren of these same Gilded Age progenitors. And while many in the rising generation continued their sponsorship of traditional models, a serious and substantial group of aesthetically minded heirs broke ground for an emerging modernism and national art forms, both as enlightened patrons and as artists themselves.

Howard Gardiner Cushing was a key figure in this group. Born just after the Civil War, he was a serious and committed painter who followed a Harvard education with five years of intensive study at the Académie Julian in Paris. Cushing, a contemporary tells us, made an early reputation with his brilliant and sympathetic portraits.[5] He was also noted for his interiors and his murals, some of which are clearly inspired by Italian landscapes or Asian models. Two of his paintings in this collection (*Interior with Child and Toy Duck* (cat. 77) and *Interior with Mother and Child* (cat. 76) (both about 1908) reproduce some of

his decorative work, and the Asian influence is apparent. Most likely this is a response to the artistic currents of the day, but perhaps there is also a lingering inspiration from the China Trader ancestor who found Asia so much more "civilized" than New England. Cushing's true portraits (as opposed to his scenes that include portraits in larger compositions) in this collection are very personal, and perhaps this intimacy, along with their sparkling white undercoats, lends them a kind of radiance. Portraits of his wife, Ethel—both *Woman in White (Mrs. Howard Gardiner Cushing* (cat. 74) (1905) and the prize-winning *Ethel Cochrane Cushing (Mrs. Howard Gardiner Cushing)* (cat. 75) (1908)—have an almost ethereal cast, and *Mrs. Cushing and Her Sister Ann (The Blue Porch)* (cat. 78) (1908), using his wife and her sister as models, has come down to us through the years as the quintessential Newport image, capturing the light and atmosphere of a summer afternoon. Cushing's early death in 1916 at the age of forty-seven shook the Newport community and moved his friends to erect the Newport Art Museum's Cushing Memorial Gallery in his honor in 1919.

Howard Cushing was a source of inspiration to many younger artists, including, Gertrude Vanderbilt Whitney, his friend since childhood. Cushing actively encouraged Mrs. Whitney as she wrestled with the self-imposed tensions of following her artistic inclinations against the restrictive female social role that was expected of her. Fortunately, Whitney's talents won out and she emerged in the early twentieth century as both an American sculptor who broke the mold for women artists with her monumental public commissions and a truly great patron. Her founding in 1930 of the Whitney Museum of American Art was the most enduring and visible of her gifts to individual artists and, indeed, to an entire generation of creative Americans.

Other socialites also divided their lives between the arts and High Society. Henry Clews Jr., for example, was another sculptor and Newport summer resident of the era (1920). His handsome self-portrait (cat. 160) in bronze is matched by the one he sculpted of his wife, Marie Clews (cat. 161), a most elegant, fashionable hostess.

By the beginning of the twentieth century, indeed, the burgeoning arts colony in Newport was so intertwined with the seasonal summer colony that in 1912 there was established an Art Association.[6] Driving forces behind the organization and success of the Art Association of Newport were artist John Elliott and his wife, Maud Howe Elliot, whose 1877 portrait by Benjamin Porter shows her in her fashionable youth. Two 1914 portraits by founders of this association, now the Newport Art Museum, are included in this collection: *Mary Burnett Grosvenor* (cat. 119) by Albert Sterner and *Mary Howe (Mrs. Walter Bruce Howe)* (cat. 118) by William Sergeant Kendall.

Realism—the true likeness of a face—was the paramount virtue in portrait painting through the late nineteenth century. The desire for true likeness—at its best infused with a recognizable spark of the sitter's personality—is never completely absent from portrait making. Nonetheless, portraits painted from the early twentieth century on take on a new dimension because photography has come into its own. Since the turn of the century, all people have become their own image makers, and realistic likeness, if that is the full concern, is a click of the shutter away. A serious artist paints in a thoughtful tension with what may be achieved through realistic photography. For many of the twentieth-century artists in the collection of Newportraits, there is an increasing sense of using artistic style to explore the sitter as if he or she were an object. We may see some of the beginnings of this tendency in John White Alexander's turn-of-the-century portrait of young Frances Brooks (cat. 49). The girl, though elegant herself, has become less important than the pattern of shapes on the surface of the canvas. The curved positioning of the subject's body, the flat, decorative quality of the presentation, even the arts-and-crafts mode of the frame all demonstrate the influence of the art nouveau movement on this progressive painter.

As the century moves forward, a strong interest in the avant-garde of modern art was evidenced in Newport mainly as patronage. However, the portrait artists among the Newporters in the collection are themselves largely realists. Robert Hale Ives Gammell, for instance, was a confirmed realist who believed that only the classical forms would endure. Descended from a long line of Browns, Ives, and Gammells, he was well known for his historical murals, some of which are in the Rhode Island State House in Providence. His portraits in this collection—*William Lansing Hodgman* (cat. 125), *Bessie Gardner Bowen Gammell* (cat. 126), and *Hope Hodgman Powel Alexander* (cat. 127)—are traditional, precise, and nearly photographic. Their own family members often sat for artists from upper-class society; Hope Curtis Drury in 1921 used her twin daughters, Hope and Kate (cat. 120 & 121), with their golden curls and wide china-blue eyes, to fashion twin pastel portraits. Similarly, in the comfortable likeness of Bradford Norman (cat. 137) reading his newspaper, Mabel Norman Cerio affectionately depicts her father as though discovered in a private activity. The Normans were local landholders and the creators of several public utilities. The family took an early lead as local benefactors; Mabel's great gift was the dedication through her will of the family's Middletown farm as the Norman Bird Sanctuary. And from Jamestown, the artist and preservationist Catharine Wright catches her son Ellicott Wright (cat. 179) practicing the clarinet in a fond and highly informal manner.

Well known among these Newport realists was the portrait painter Olive Bigelow Pell. After intensive art studies in New York, Paris, and London in her youth, she became an illustrator for magazines and children's books. In 1927, in a second marriage for both, she married New York Congressman Herbert Claiborne Pell. With Pell, she traveled to his assigned diplomatic posts in Hungary and Portugal. In Portugal during World War II, she turned her portrait-making abilities into successful fund-raising for the Red Cross by painting "anyone" willing to sit and pay the price.

Tremendously gifted in music, talented as a writer, and blessed as an artist, she is recalled as being most passionately interested in people. Pell's portraits reflect this. Her cheerful flat surfaces, drenched in the sunshine of good spirits and optimism, show her subject—usually her family members—to advantage. She painted compulsively. Her daughter Pyrma remembered that for the prize-winning portrait *Pyrma Tilton* (cat. 166) (c. 1920), she was summarily snatched up, placed on a cushion on the top of the piano, surrounded by flowers, and made to hold her pose for what seemed to a child "long hours."[7]

Best known among Olive Bigelow Pell's Newport family portraits is the 1928 work *Herbert and Son Claiborne Pell* (cat. 168) (1927), especially since in 1961 Claiborne Pell was to follow his father into a lifetime of national service as Rhode Island's U.S. Senator. Beautifully composed as a formal circle, the elder Pell seems to be instructing his nine-year-old child even as the two interlace their fingers, creating a ring of responsible expectations and deep affection that was the essence of the relationship between father and son.

Olive Bigelow Pell's paintings here are in several ways typical of many other twentieth-century portraits in this collection. On the one hand, there are many charming pictures recording a new emphasis on domesticity. On the other, there is evidence in these portraits of activity in an enlarged public sphere, indeed an international domain. So for Pell, there was no dichotomy between painting diplomatic portraits and painting *Pells at Tea* (cat. 169) (1933).

The strength of William Rankin's 1932 portrait *Mrs. Cornelius Vanderbilt II with Her Daughters Gladys and Gertude* (cat. 169) is its domestic intimacy. One could be forgiven for expecting the opposite, for by this time Mrs. Cornelius Vanderbilt II (Alice) had spent her life as one of the world's wealthiest women, her daughter Gertrude (Mrs. Harry Payne Whitney) was an internationally celebrated artist and founder of a great museum, and her youngest daughter, Gladys (the Countess László Széchényi of Hungary), was European aristocracy and the wife of a Hungarian minister. The background of the painting is the princely library of The Breakers, with its majestic carved stone

chimneypiece from a French chateau. Despite the grandeur of the setting, this Vanderbilt portrait speaks not of power but of family loyalty and simple affection. Another interesting domestic portrait is the ivory triptych of the Hill family by an unidentified artist. Nathaniel Hill, heir to the Campbell's Soup fortune, sits in relaxed attitude on the right side, his little sister in party clothes shares the left panel with a pile of birthday gifts, and in the central panel, their mother, Elinor Dorrance Hill (cat. 188), seems to float in the soft, pink chiffon of her gown.

Silhouettes are another delightful testimony to the emphasis on the private sphere. These traditional profile portraits, very much in vogue in the 1920s and 1930s, presented intimate, family statements. Indeed, a silhouette artist such as Baroness Eveline von Meydell would visit the area and become the houseguest of each family in turn; she would sit among them daily and capture their essences with her sharp scissors. In addition to the snipped likeness of many children (*The Stoner Children* [cat. 58], *The Gillespie Children* [cat. 59], *Hugh D. Auchincloss with His Dogs* [cat. 133], and *Betty Morris and Flicka* [cat. 110], for some examples) and the profiles of adults (*William Sheffield III and Faithful Fritz*) (cat. 134), there are entire charming scenes that are like shadow puppet plays. The von Meydell silhouette portrait *The Morris Family* (cat. 109), for example, is a wondrous, staged moment of exquisitely delicate tracework that encompasses the parents, the two daughters, and the family pets in a setting of latticed light and shadow, all backlit against the distant image of the Newport family home, Malbone. The appealing 1932 portrait of Hugh D. Auchincloss III (cat. 133), a wee boy perched between two enormous and eager begging dogs, is superimposed on a faint landscape of the family's Hammersmith Farm after harvest with catboats sailing beyond.

Paintings of their children were as important to twentieth-century Newport society parents as they were to the rising class in the nineteenth century. While the more recent works in the collection again emphasize children and young people, they are most typically presented without grandeur, in poses that stress their childlikeness. They are less the little adult, more the small heart tugger whose fleeting innocence must be recorded. The Astor grandson Thornton Wilson (cat. 178) is shown with his arm around his dog. Pastels of little girls abound, from Alfred Hoen's highly formal composition of sisters, *Alletta and Betty Morris* (cat. 107) (about 1921), with its perspective especially created for its planned location in the ballroom of the family's New York home; to Wilfred Gabriel de Glehn's poignant 1930 pair of sisters Jane Pope (cat. 175) and Mary Pope (cat. 174); to John Ferris Connah's appealing and informal 1935 portrait of winsome little Jacqueline Bouvier (cat. 128).

An exception among schoolgirl portraits is the commanding oil portrait of young Sylvia Széchényi (cat. 98), painted by family cousin and famous society portrait painter Philip Alexius de László de Lombos. A Vanderbilt horsewoman from a tender age, the thirteen-year-old girl had insisted upon posing in her riding habit instead of the typical feminine dress. The costume, her aristocratic posture, and a touch of pride in her lovely features lend this young lady an air of directness and authority unusual among the modern portraits of children in this collection. De László was a much sought-after artist, and his talent and highly romantic eye are evident in all his works in this collection. In his portrait of Sylvia Széchényi's father, the Count László Széchényi (cat. 96) appears wearing a sash, sword, and eye patch like the hero of some swashbuckling fiction. Mary Ridgely Carter Beck and her wolfhound (cat. 183) are painted in 1934 in a dramatic windswept attitude characteristic of Thomas Gainsborough 150 years earlier. Even the more direct portrait *Anita Strawbridge Grosvenor* (cat. 184) (1931) has a sweetly romantic aura that enhances the young woman's blonde beauty.

Young Sylvia Széchényi was not unusual in wishing her portrait to identify her as a rider and lover of horses. The equestrian tradition among Newport's resort colony has continued to remain strong from the nineteenth century. Verner Reed (cat. 154) is painted in the pink coat of the hunt by Raymond Perry Rogers Neilson, just as Bjorn Egeli presents E. Taylor Chewning (cat. 153) and William Wood-Prince (cat. 152) in this highly flattering traditional gentleman's attire. Here in Newport, expert horsewoman Janet Auchincloss (cat. 150) was rendered in an autumnal profile equestrian portrait by Richard M. Newton, as was Frederick Henry Prince (cat. 149) in an evocative hunt scene by Sir Alfred J. Munnings.

The other great Newport sport for wealthy American gentlemen was and remains yachting. The safe anchorage of Newport Harbor, the invitingly pleasant waters of Narragansett Bay, and the bracing challenge of the Atlantic Ocean have had the lure of a siren for the great yachtsmen of Newport. Many of the men pictured in this collection were skilled competitive sailors, while both James Gordon Bennett Jr. (cat. 156) and Arthur Curtiss James (cat. 155) were distinguished Commodores of the New York Yacht Club. The skipper with the greatest reputation was probably Harold Stirling Vanderbilt (cat. 102) (painted by von Dresser), who successfully defended the America's cup three times in the mighty J-boats *Enterprise* (1930), *Rainbow* (1934), and *Ranger* (1937).

Just as Newporters gained international reputations in sports, they were noted in the larger public arena for other endeavors. In the

twentieth century, Newport's well-born sons and daughters included diplomats, a governor of the state, a U.S. senator, a First Lady, cabinet officers, and the heads of boards, publishing enterprises, international corporations, major museums, and charitable foundations.

From the perspective of the lovely old city herself, perhaps the most important public works of these characters in the collection of Newportraits were those undertaken to beautify and preserve Newport. Joseph Coletti's bust (cat. 65) (1927) of the young John Nicholas Brown was made only three years after Brown's gift of the neo-Gothic chapel to St. George's School. The Brick Market was also restored through his generosity. The entire Summer Colony became active in preservation after World War II. Katherine U. Warren (cat. 186) became the unstoppable driving force behind the founding of the Preservation Society of Newport County (PSNC) in 1945. This organization, with its mission to preserve the best of Newport's past, pioneered the salvaging and historic restoration of a number of key properties, from the 1748 Hunter House to The Elms of 1903. The Countess László Széchényi (née Gladys Vanderbilt), by making it possible for the society to open The Breakers to the public, created the means for the early work of rescue and restoration. As a collective organization, the society empowered individual families to save or donate their properties. For instance, the Rives Family, knowing the larger organization was its ally, waged court battles to save Kingscote. Harold Stirling Vanderbilt purchased back Marble House from the heirs of Frederick Henry Prince so that he could donate it to the society. At the time René Bouché was painting his courtly portrait of Noreen Stonor Drexel (cat. 62) (1960), the Society leader was laboring with her friends to preserve The Elms from being replaced by a shopping mall. The Casino, an architecturally unique structure once the very heart of social resort life, was saved only through the efforts and inventiveness of James H. Van Alen (portrayed by Lucas Guaneri and Augustin Segura) (cat. 157 & 159), whose idea for an International Tennis Hall of Fame and Museum gave new life to the restoration of this priceless historic complex. In more recent times, John Winslow (wax relief by Ethel Frances Mundy; not reproduced here) succeeded Katherine Warren as an active and determined President of the Preservation Society. Newport preservation efforts continued in the historic colonial neighborhoods through the commitment of tobacco heiress Doris Duke. Duke's 1924 oil portrait by Stella-May Da Costa (cat. 173, not reproduced here) shows her at about the time she inherited the Duke millions. It was in 1968, however, that she established the Newport Restoration Foundation, which saved, restored, and returned to daily use in the community more than eighty important eighteenth-century properties. The presence of the foundation houses

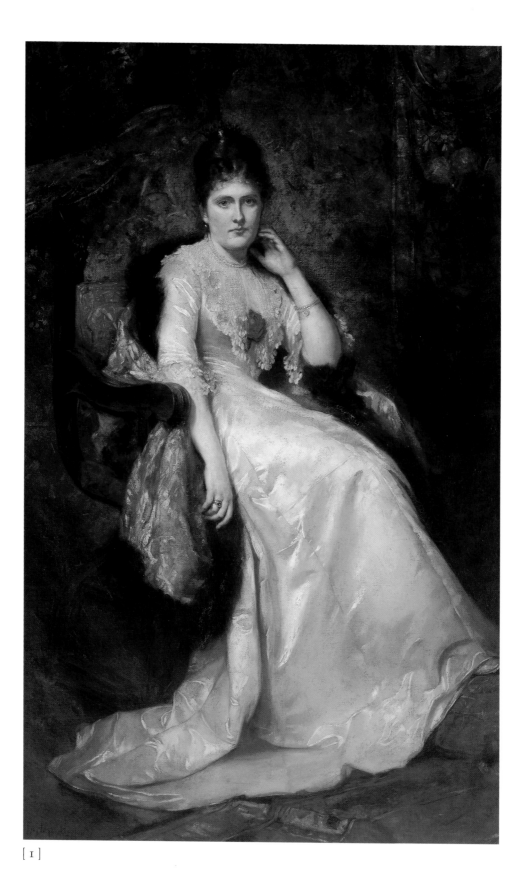

I. Benjamin Curtis Porter

AMERICAN, 1845–1908

Maud Howe (Elliott), 1877

Oil on canvas, 76 by 48 inches
Collection of the Newport Art Museum
Gift of the Members of the Newport Art Museum

In July 1912, the newly formed Art Association of Newport opened its first exhibition, *The First Annual Exhibition of Pictures by Living American Artists*. It was a remarkable event that brought together most of the avant-garde artists of the early twentieth century one year before many of them would exhibit together at the important Armory Show in New York.

Maud Howe Elliott (1854–1948) was the force behind the new association, now the Newport Art Museum, and she would serve as its secretary well into the 1940s. Maud was the daughter of Dr. Samuel Gridley Howe and the suffragette Julia Ward Howe of Boston. The Howe family summered in Portsmouth at Oak Glen and were very much part of the Aquidneck Island's literati (which included luminaries such as Longfellow), who gathered together to exchange intellectual ideas. Daughter Maud was a writer, and her husband, John Elliott, was one of the founding members of the Art Association of Newport and was among its first exhibitors and teachers.

The portrait of Maud Howe was painted in 1877, before she married John Elliott. It hung for many years in the family's Beacon Street home in Boston. Benjamin Curtis Porter was a Boston artist who had studied in Paris and won medals at the Paris exhibitions of 1900, 1901, and 1904. A respected and popular portrait painter, he was in much demand in both Boston and Newport. His 1899 portrait of Cornelius Vanderbilt II is also included in *Newportraits*.

to minor British artists who plied their trade in the New World and to engravings and mezzotints they imported with them of European portraits. Feke followed accepted conventions of portraiture. Basing his work on European images, he executed paintings in the crisp and realistic descriptive style favored by colonial artists before the Revolution.

Records indicate that Feke left Newport for Bermuda in 1750 and died there a few years later.

The two examples included in this exhibition represent the standard formulas he favored: the portrait bust within an oval and the three-quarter figure, seated or standing, before an open "window," its view evoking the profession of the sitter. Both compositions were used by painters throughout the colonial period.

2. Robert Feke

AMERICAN, 1707–1752

Mary Winthrop Wanton, about 1740

Oil on canvas, 30 by 25 inches
Collection of the Redwood Library and Athenaeum, Newport, Rhode Island
Gift or bequest of Angelica Gardner between 1843 and 1860

Mary Winthrop Wanton (1707–1767), the daughter of Ann Dudley and John Winthrop, was also the granddaughter of Governor Joseph Dudley of Connecticut. Robert Feke painted her portrait during his stay in Newport (1740–1750), probably in his Touro Street home. The painting was paired with the portrait of her husband; both now hang in the Redwood Library. Her husband, Joseph Wanton, would serve as the governor of Rhode Island from 1769 to 1775.

Feke has used the popular oval format within a rectangular canvas in a scale appropriate for smaller domestic portraits. The painted oval frame within a frame was derived from engravings of European portrait paintings, which reproduced images of real, three-dimensional frames on the printed sheet as two-dimensional ovals.

Mrs. Wanton's sharply delineated features and rigid pose are typical of Feke's style. Her décolletage was altered in 1859 at the request of the Directors of the Redwood Library. Jane Stuart, daughter of Gilbert Stuart and a portrait painter in her own right, added the floral bouquet to conceal the lady's cleavage. The flowers remain there today as evidence of changing styles and morality.

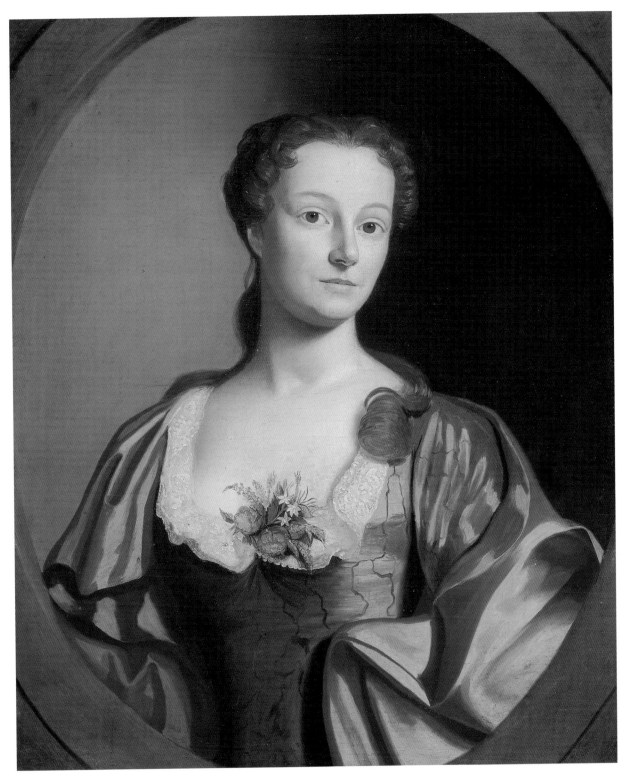

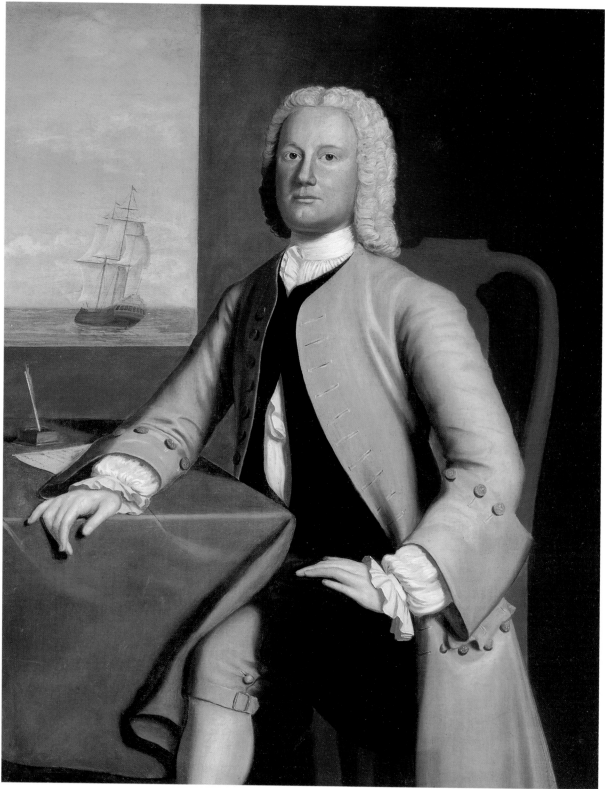

3. Attributed to Robert Feke

AMERICAN, 1707–1752

Captain Philip Wilkinson, about 1740

Oil on canvas, 50 by 40 inches
Collection of the Redwood Library and Athenaeum, Newport, Rhode Island
Gift of Catherine V. Allen

This portrait of Captain Wilkinson has been attributed to Robert Feke based on its stylistic elements and the apparent date of the work. Captain Wilkinson is seated on a Queen Ann–style chair. Such chairs appeared in Newport in the late 1730s and were produced by important workshops, such as those of the Townsend and Goddard families. By the 1730s, Newport was producing some of the finest pieces of furniture in the colonies. The painter has not only described the curved back and carved shell at the top of the slat, but he has also indicated that it is made of imported mahogany, wealthy patrons' material of choice. The shell appears on a number of chairs that are documented to be from Newport.

The artist has painted this portrait in the crisp, descriptive style characteristic of all of Feke's works. Captain Wilkinson was a Newport merchant obviously involved with the shipping trade. In the window, a space traditionally reserved as a comment on the profession of the sitter, a ship has set out to sea. The chair, Wilkinson's clothes, and his demeanor declare his success as a merchant.

Joseph Blackburn, about 1700–1780

Joseph Blackburn arrived in Newport in 1754. An Englishman trained in the style of English Rococo portrait painting, he had spent two years in Bermuda before arriving in the colonies. From Newport, the painter continued on to Boston and Portsmouth, New Hampshire, where he produced a number of notable portraits. He returned to London in 1763. His last dated portrait was painted there in 1778. Blackburn was a master at the painting of textiles. In England, he had probably painted the elegant gowns of British patrons, while more fashionable and capable artists painted their faces and hands. He brought this skillful handling of textures with him to the New World. Here, Blackburn's lustrous painted fabrics gave his portraits an elegance not seen in the more

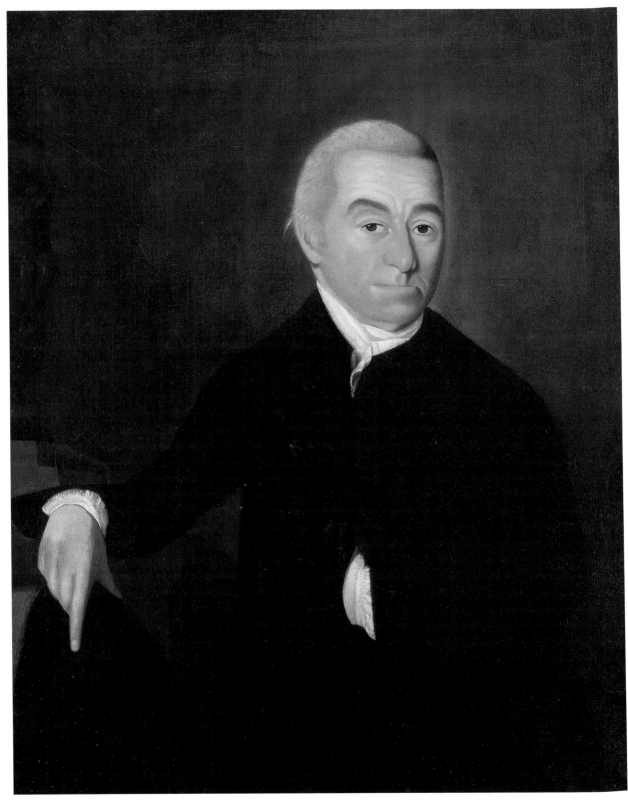

Jacob Rodriguez Rivera (1717–1789) was a member of a prominent Portuguese Jewish family in Newport. A merchant, he introduced the manufacture of spermaceti candles to Newport; it was an industry closely related to the whaling industry of New Bedford. He became a member of the Redwood Library in 1758.

Rivera's name appears on the roster of important members of Touro Synagogue who are buried in the Jewish cemetery at the top of Touro Street. The portrait was painted on commission for Samuel Rodman, a wealthy merchant in Newport and New Bedford who began his business in Rivera's counting house. It is now accepted that the unsigned portrait is by Gilbert Stuart, although it had been attributed tentatively to Edward Savage, an artist who never lived in Newport.

The portrait was presented to the Redwood Library by the great-granddaughters of Samuel Rodman.

I I. Gilbert Stuart

AMERICAN, 1755–1828

Benjamin Waterhouse, about 1776

Oil on canvas, 22¼ by 18 inches
Collection of the Redwood Library and Athenaeum, Newport, Rhode Island
Bequest of Louisa Lee Waterhouse (Mrs. Benjamin Waterhouse), 1864

The portrait of Benjamin Waterhouse (1754–1846) was painted in London after Gilbert Stuart had joined him there. The young men had grown up as friends in Newport, and it was at Waterhouse's urging that Stuart followed him to London. Benjamin Waterhouse was the son of Timothy and Hannah Proud Waterhouse of Newport. He studied medicine in London and Edinburgh and received his degree from the University of Leyden in 1780. He opened his practice in Newport and was one of the founders of the Harvard Medical School in 1783. It was Dr. Waterhouse who introduced William Jenner's smallpox vaccine to America. From 1784 to 1791, he was a professor of natural history at Brown College. The open book that Stuart has placed before his friend appears to be a medical text. It is evident in this small portrait that Stuart was beginning to develop a more capable style after his recent arrival in England.

The portrait was given to the Redwood Library by Waterhouse's widow, Louisa Lee Waterhouse.

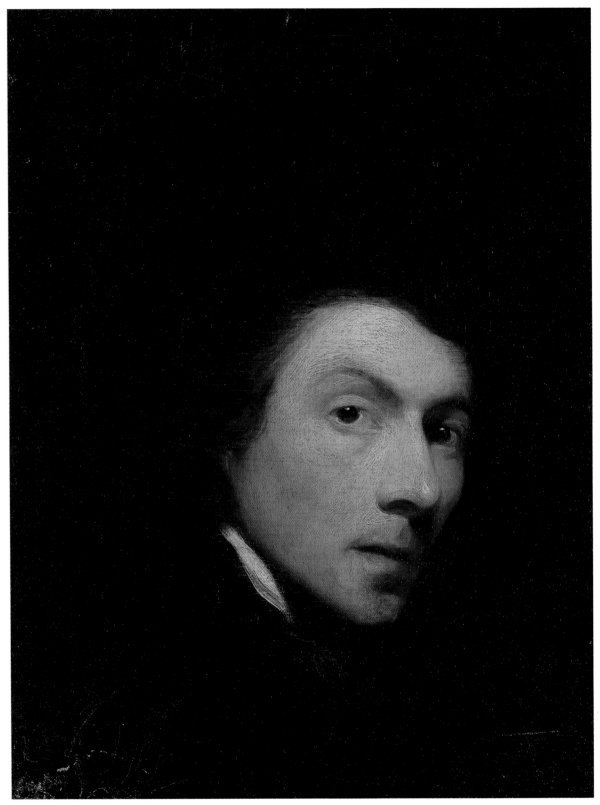

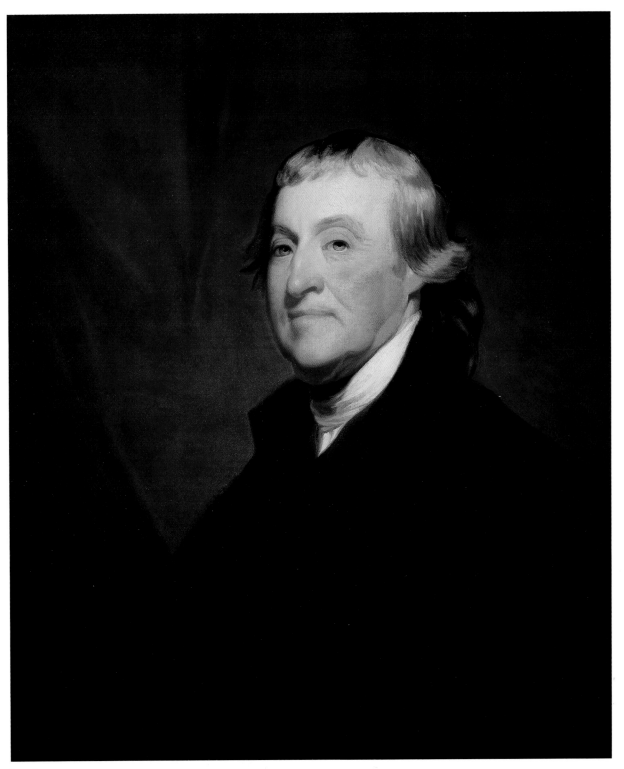

The portrait was given to the Newport Art Museum in 1992 by the widow of John Howland Gibbs Pell, a direct descendant of George Gibbs. Mrs. Pell donated a twentieth-century copy of the companion portrait of Gibbs's wife, Mary Channing Gibbs, to the museum at the same time.

14. P. P. Caproni and Bros. after a plaster original by John Henri Isaac Browere

AMERICAN, 1792–1834

Gilbert Stuart, about 1831

Marble, 28½ inches high
Collection of the Redwood Library and Athenaeum, Newport, Rhode Island
Gift of Roderick Terry Jr., 1931

The Redwood Library image is a twentieth-century copy of Browere's plaster bust, now in the Newport Historical Society. The copy was made by P. P. Caproni and Bros. of Boston. Browere studied at Columbia College and in Europe. He returned to New York in 1817 and began to make plaster life masks of famous men in order to cast them in bronze. This marble bust retains the facial details of the life mask. The bust is draped in the manner of neoclassical sculpture and set on a marble base.

15. Reuben Moulthrop

AMERICAN, 1763–1814

Reverend Ezra Stiles, about 1812

Oil on canvas, 36 by 29 inches
Collection of the Redwood Library and Athenaeum, Newport, Rhode Island
Gift of Mrs. E. L. Stone, 1892

Dr. Ezra Stiles (1727–1795) was a 1746 graduate of Yale College, pastor of the Second Congregational Church of Newport, and president of Yale College from 1778 to 1795. He served as the librarian of the Redwood Library at various times between 1756 and 1776; he increased the library's holdings in philosophy, history, antiquities, and the physical sciences. Reuben Moulthrop was a portrait and miniature painter active in New Haven, Connecticut. His portrait of Stiles was painted some time after the gentleman's death.

The portrait was presented to the Redwood Library by a descendant of Ezra Stiles.

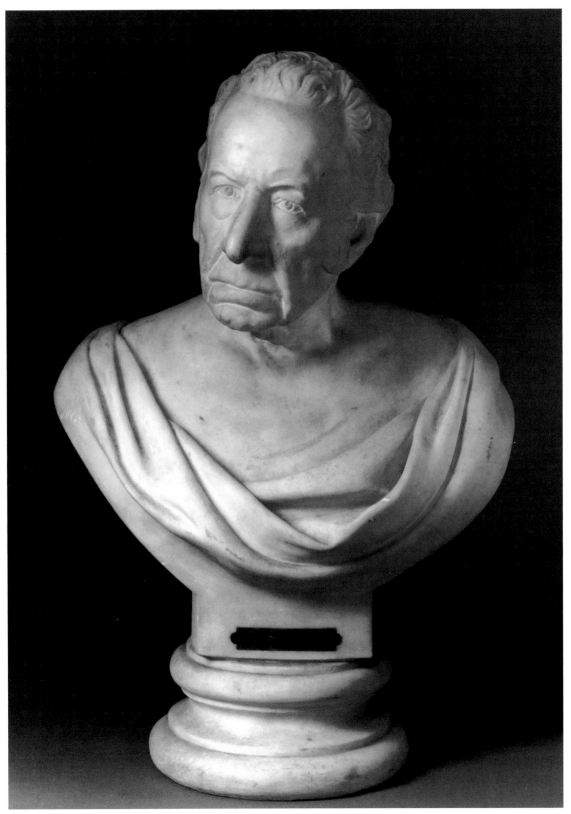

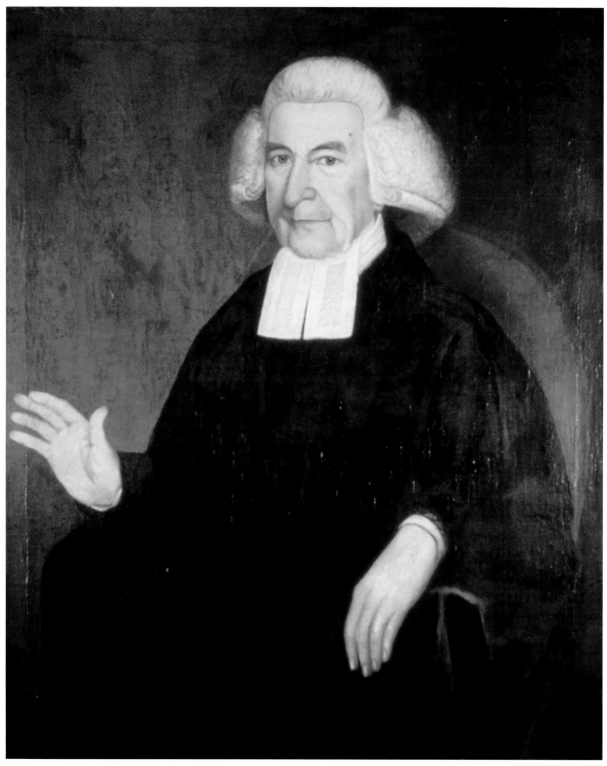

16. Samuel King

AMERICAN, 1749–1819

Abraham Redwood, about 1790

Oil on canvas, 42½ by 33½ inches
Collection of the Redwood Library and Athenaeum, Newport, Rhode Island
Bequest of Mrs. Edward A. Grossman (Gertrude Ellery Boker Grossman,
descendant of Ezra Stiles), 1950

Abraham Redwood (1709–1788) was the son of Abraham and Mehetable Langford Redwood. The senior Redwood managed a large sugar plantation in Antigua before his family settled in Newport between 1712 and 1717. They were members of the Society of Friends and worshiped at the Friends' Meeting House in Newport.

The junior Abraham was educated in Philadelphia, inherited the plantation, and improved on the already successful sugar trade; he thus became one of the wealthiest merchants of Newport. In 1726, he married Martha Coggeshall. They settled in Newport and produced nine children. In 1747, he gave money and books toward the founding of the Redwood Library, the institution that still bears his name. This portrait by Samuel King shows the gentleman seated in a chair of dark polished wood (mahogany) and, quite appropriately, holding a leather-bound edition of Alexander Pope's *Essay on Man*. The artist portrays his subject in the clearly defined and somewhat unflattering manner of the colonial portrait painters. Samuel King (1749–1819) was a respected portrait and miniature painter, who lived in Newport most of his life, except for a brief stay in Salem, Massachusetts. King taught Edward Malbone and Washington Allston and imparted to them the tradition of non-painterly colonial painting.

17. Sir Thomas Lawrence

ENGLISH, 1769–1830

Abraham Redwood, 1791

Oil on canvas, 31 by 25½ inches
Collection of the Redwood Library and Athenaeum, Newport, Rhode Island
Gift of John Purssord, Esq., 1860

This Abraham Redwood (1764–1838) was the grandson of Abraham Redwood, founding member of the Redwood Library. He was born in Newport and moved to England, where he died in 1838. That the por-

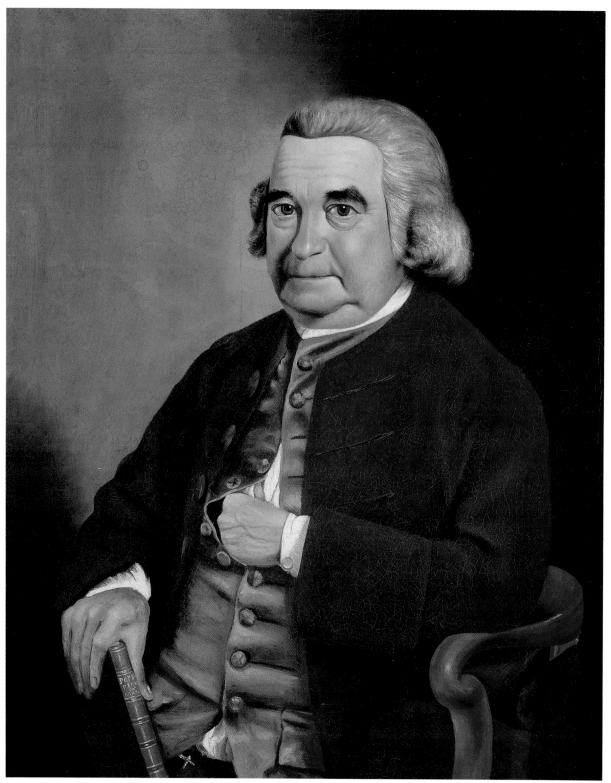

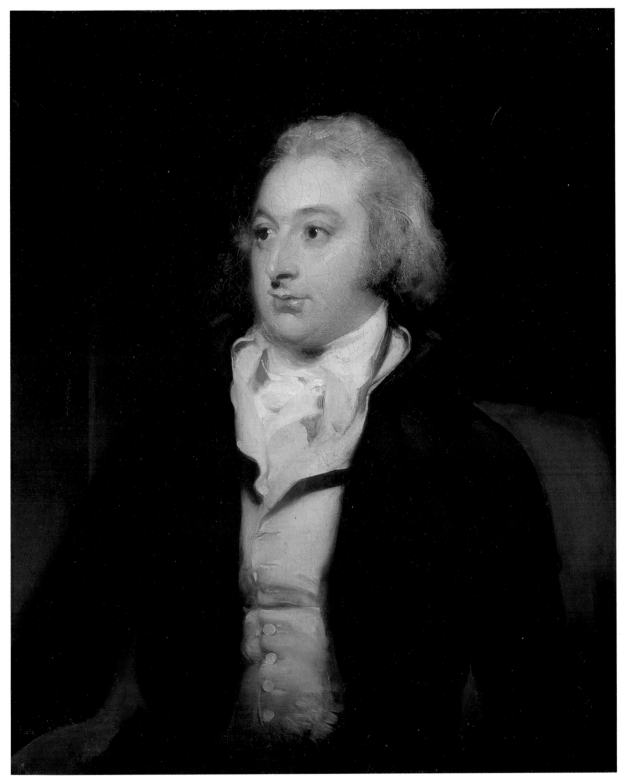

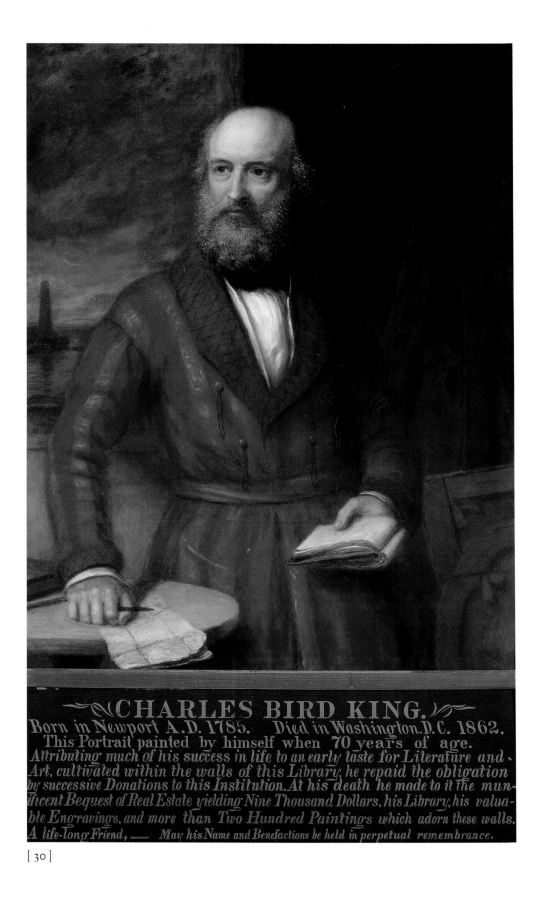

CHARLES BIRD KING.

Born in Newport A.D. 1785. Died in Washington.D.C. 1862.

This Portrait painted by himself when 70 years of age.
Attributing much of his success in life to an early taste for Literature and
Art, cultivated within the walls of this Library, he repaid the obligation
by successive Donations to this Institution. At his death he made to it the mun-
ificent Bequest of Real Estate yielding Nine Thousand Dollars, his Library, his valua-
ble Engravings, and more than Two Hundred Paintings which adorn these walls.
A life-long Friend,_____ May his Name and Benefactions be held in perpetual remembrance.

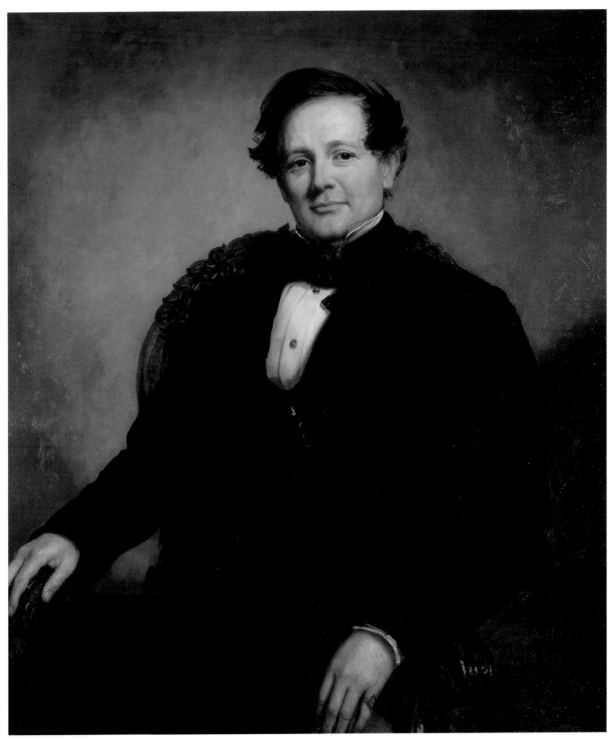

The Gilded Age

*S*UMMER RESIDENTS before the Civil War stayed for extended periods in hotels on Bellevue Avenue. After the war, the fashion turned to building summer residences along and near the avenue. The first were "simple cottages," among them the home of John N. A. Griswold, built in 1864 by Richard Morris Hunt and now the home of the Newport Art Museum. As the century progressed, the cottages became more and more elegant, and their owners, moving up from New York and Philadelphia, built increasingly impressive domiciles.

The summer residents' portraits reflect their sense of self. They called on artists from abroad or had their portraits done during visits to Europe. Some American artists, such as John Singer Sargent, returned from Europe to paint members of this country's most respected families. As the century drew to a close, the simpler world that such Newporters as Edith Wharton had written about was thus drawing to a close, and Newport society was establishing its rules of formality while it was building itself a setting of great elegance. Thus as French and Italian palaces were inspiring those building homes on Bellevue Avenue, French and Italian painters were being commissioned to portray the owners of those "palaces."

32. Unknown artist

AMERICAN, NINETEENTH CENTURY

Mrs. William Backhouse Astor Jr. (Caroline Webster Schermerhorn), about 1860

Oil on canvas
Collection of the late R. Thornton Wilson (Mary 7, 1924–June 5, 1996)

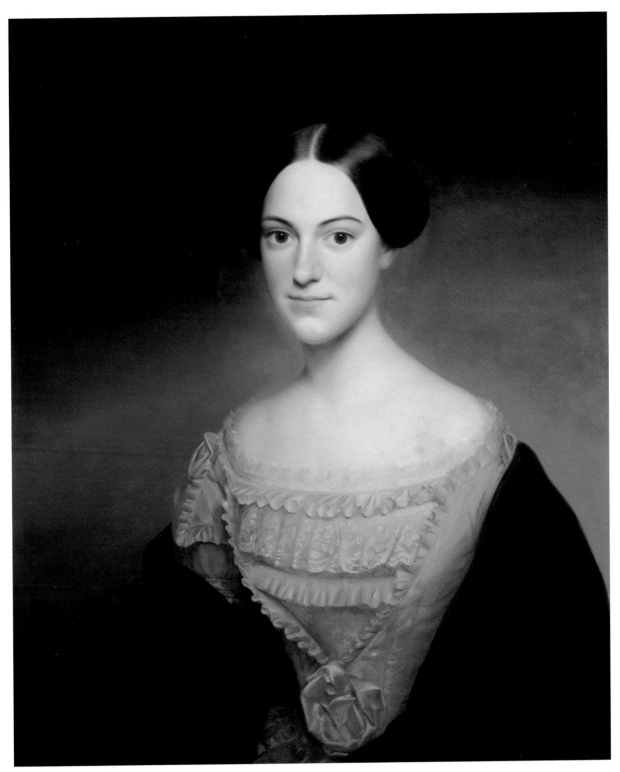

The portrait is of the youthful Caroline Webster Schermerhorn Astor (1830–1892). As the wife of William Backhouse Astor Jr., she became *the* Mrs. Astor (always referred as such), the arbiter of Newport and New York society. This portrait, by an unknown painter, shows Caroline as a young matron nearing thirty. (Incidentally, a painting by Carolus-Duran of the mature Mrs. Astor was the backdrop she used when she greeted her guests at her exclusive functions.) Her husband, William Backhouse Astor Jr., was the grandson of John Jacob Astor (1763–1848), the fur trader who arrived from Germany in 1784 and became one of America's most influential financiers.

When Mr. and Mrs. Astor bought and refurbished Beechwood (built 1851–1852), she established Newport as the summer capital of New York society.

33. **Hiram Powers**

AMERICAN, 1805–1873

Emily Astor (Mrs. James H. Van Alen), 1872–1873

Marble

Collection of Mrs. James H. Van Alen

Emily Astor (1854–1881) was the oldest daughter of Caroline Webster Schermerhorn Astor (see cat. 32) and William Backhouse Astor Jr. and the great-granddaughter of John Jacob Astor. She accompanied her parents on their European tour of 1872–1873, when she posed for Hiram Powers in Rome. Emily Astor went on to elope with James J. Van Alen in 1876. She died at the young age of twenty-eight, after only five years of marriage; she had three children.

The bust is listed among the unfinished works that were in Powers's Rome studio at the time of his death in 1873. Miss Astor's hair alone needed to be completed, and one of the studio sculptors finished the work. The piece then was shipped to Mrs. Astor in July 1873. Powers sculpted the bust in his traditional neoclassical style; the carved scarf, draped over her left shoulder, resembles a classical garment. The details of the stitching on her chemise are worked with great care.

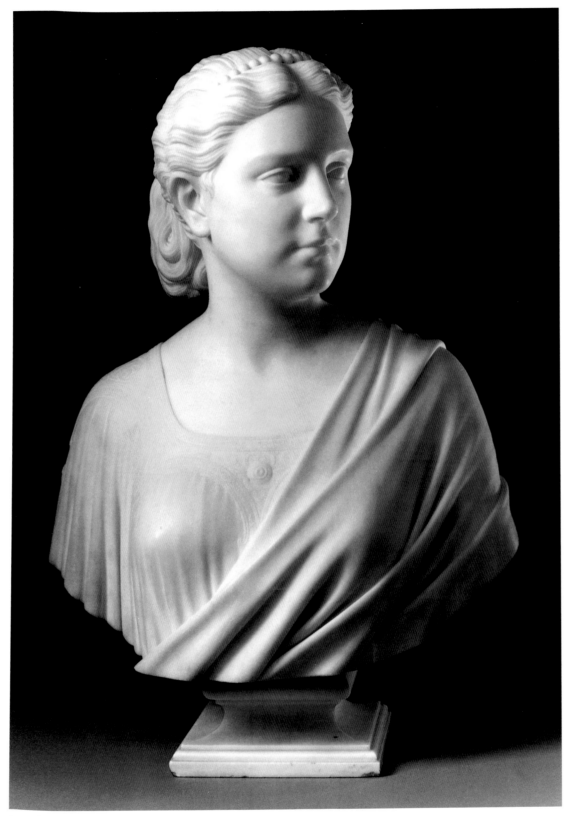

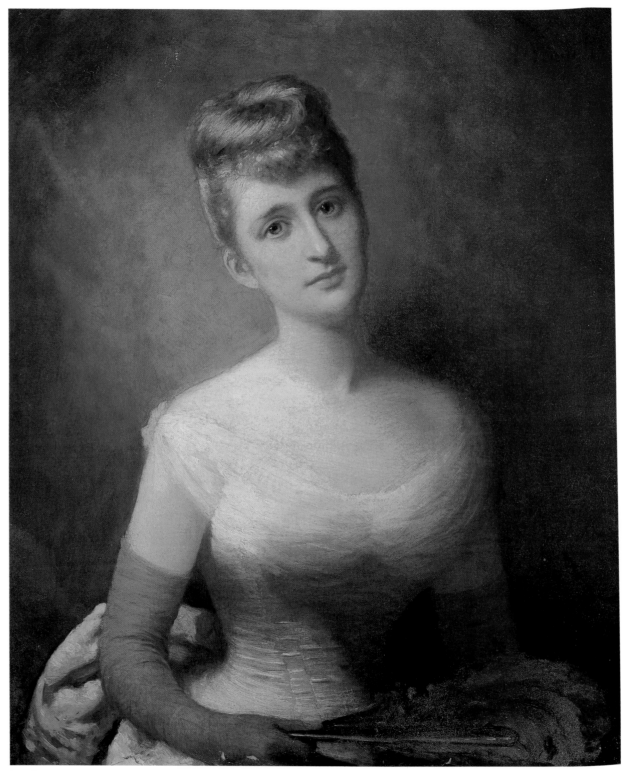

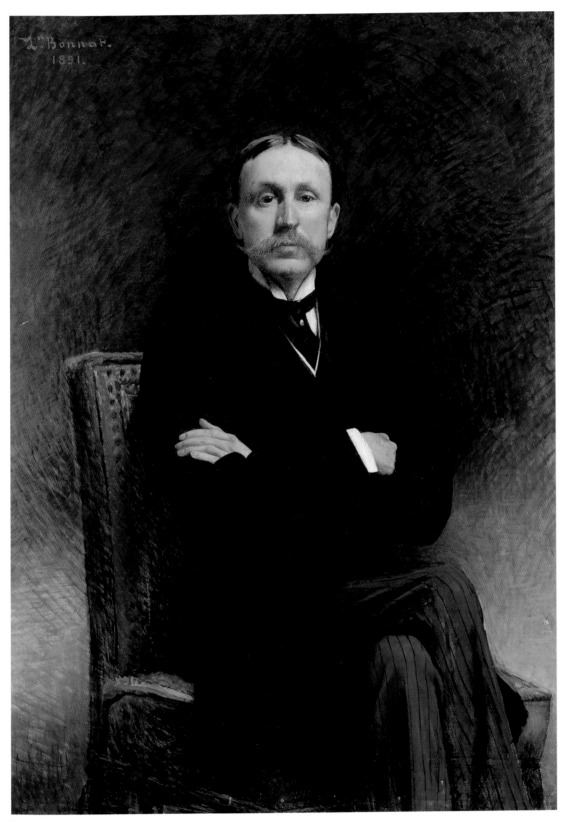

49. Luigi Simonetti

ITALIAN, EIGHTEENTH CENTURY

John Carter Brown

Marble
Collection of Eileen Gillespie Slocum

It was appropriate to have marble busts of a classical nature in private libraries. The Simonetti bust of John Carter Brown was no doubt created for that purpose. The piece was probably carved in Rome, where Mr. Brown would have posed for it during a European venture. Simonetti has depicted him in a fur-collared wrap over an open-necked shirt, more of a romantic than a traditional classical look.

50. Léon-Joseph Florentin Bonnat

FRENCH, 1833–1922

Mrs. John Carter Brown, 1889

Oil on canvas, 27 by 22 inches
Collection of Eileen Gillespie Slocum

The French painter Bonnat preferred to have his subjects come to his Paris studio to sit for portraits. He was a well-respected member of the French Academy and teacher of both European and American painters (Vinton of Boston and Eakins of Philadelphia studied with him in Paris). He was the preferred portraitist for gentlemen of his time, and he paints Mrs. Brown with the same forceful directness he used in his portraits of men (see the portrait of Ogden Goelet, cat. 43). Mrs. Brown, the former Sophia Augusta Brown, is painted in widow's black well after the death of her husband.

51. François Fleming

FRENCH

Sophia Augusta Brown Sherman (Mrs. William Watts Sherman), 1910

Oil on canvas, 33 by 27 inches
Collection of Eileen Gillespie Slocum

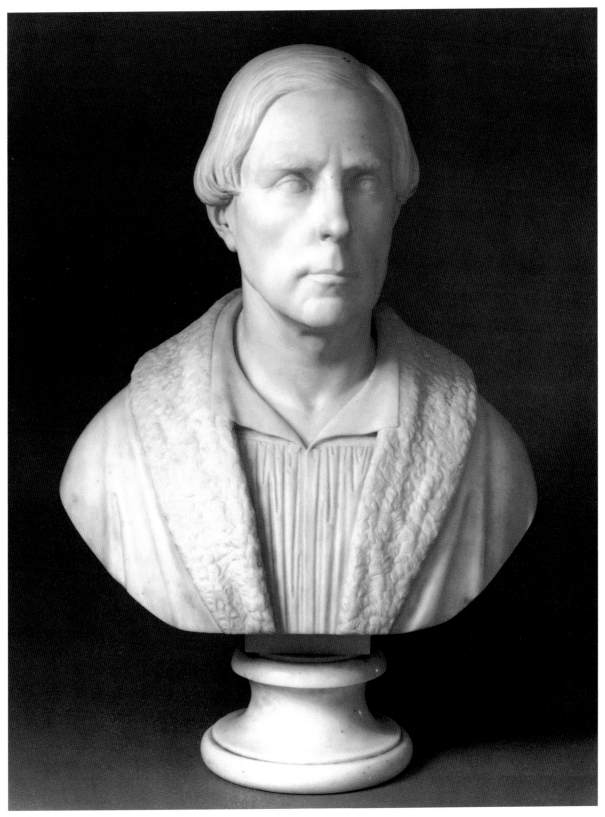

Sophia Augusta Brown was the daughter of Mr. and Mrs. John Carter Brown and the second wife of William Watts Sherman of Newport. The stylish French painter Fleming painted her portrait in 1910. Her elegantly coifed pompadour is topped by a coronet, and furs and jewelry add to her presence.

52. Laura Coombs Hills

AMERICAN, 1859–1952

Sophia Augusta Brown Sherman (Mrs. William Watts Sherman)

Miniature watercolor on ivory, 5 by 4 inches
Collection of Mr. and Mrs. John R. Drexel III

Miniature painting on ivory saw a revival in the late nineteenth and early twentieth centuries. Laura Coombs Hills, a popular portrait miniaturist and flower painter, founded the American Society of Miniature Painters. This miniature of Mrs. Sherman was probably painted before the formal portrait by Fleming.

53. Theobald Chartran

FRENCH, 1849–1907

William Watts Sherman

Oil on canvas
Collection of Eileen Gillespie Slocum

William Watts Sherman of Newport, the husband of Sophia Augusta Brown Sherman, selected a different French painter for his portrait. Theobald Chartran studied with the academic painter Alexandre Cabanel at the Ecole des Beaux Arts in Paris and gained recognition with the Prix de Rome in 1877. By the time he painted the portrait of Mr. Sherman, he had become a favored society painter. The same artist was called upon to paint a double portrait of the Sherman's two daughters in 1901.

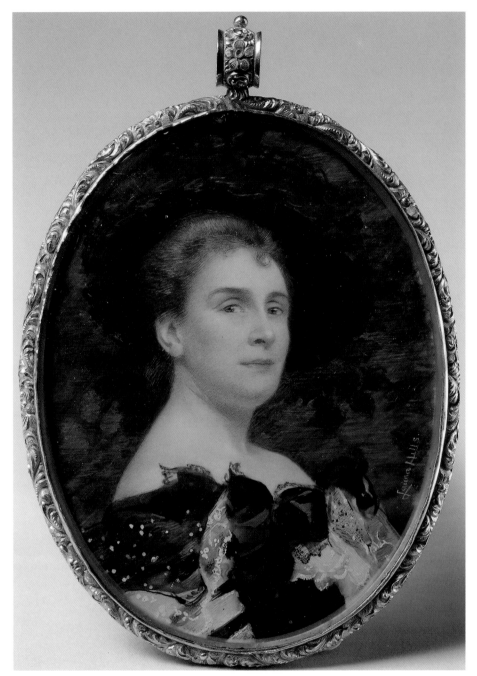

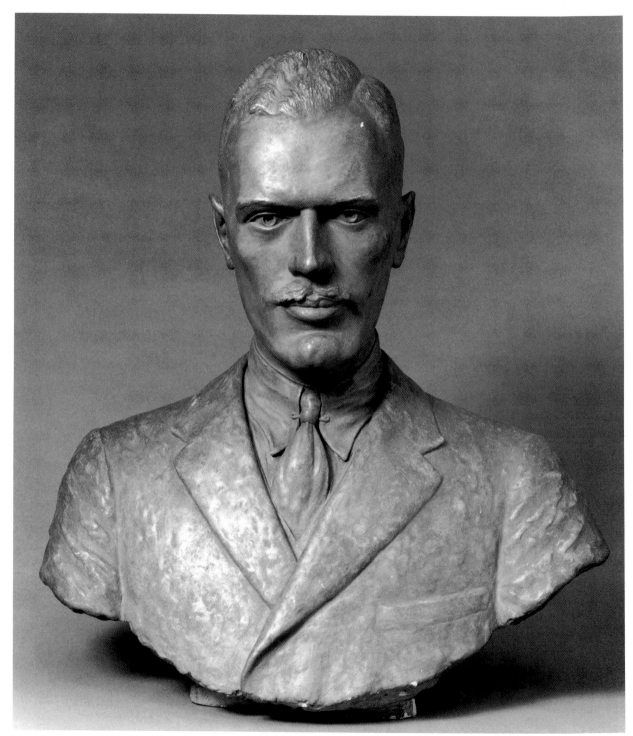

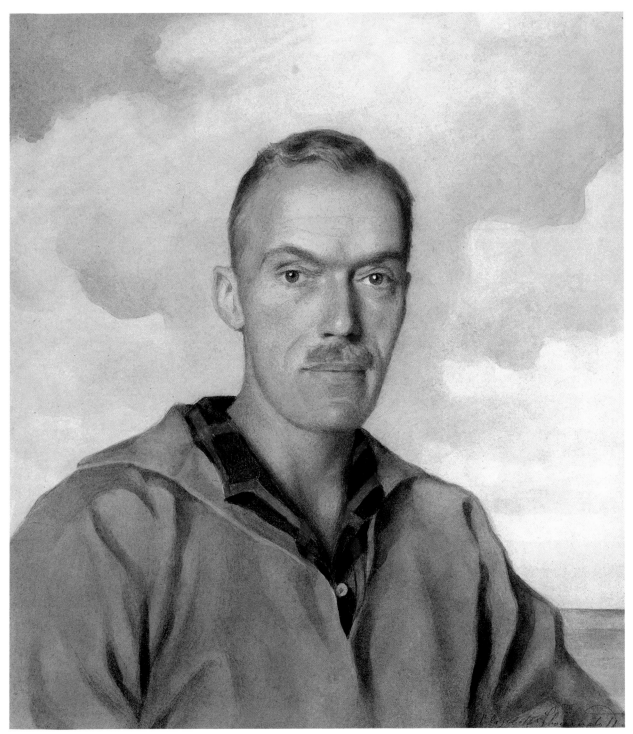

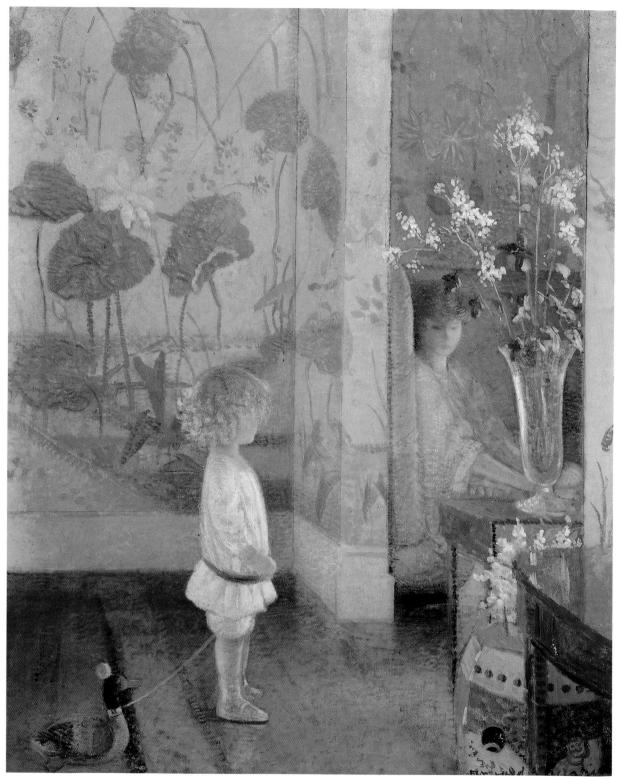

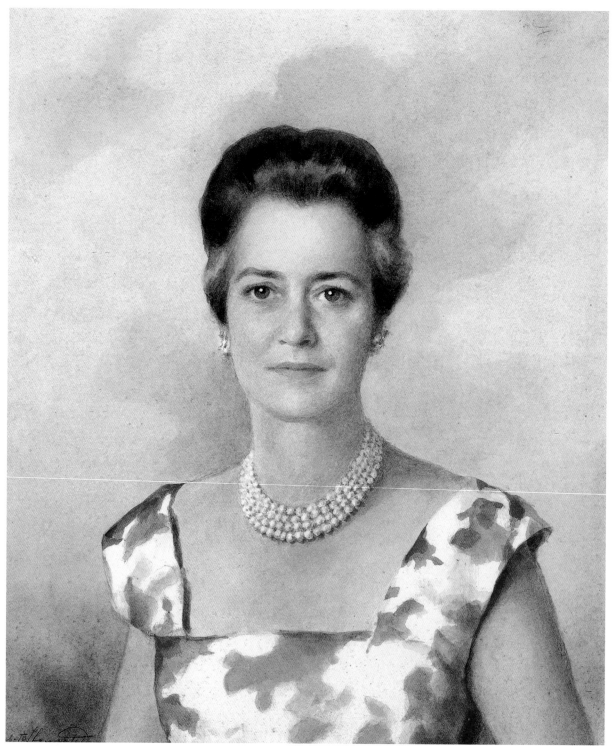

Anne Kinsolving Brown was the wife of John Nicholas Brown and a distinguished collector and scholar in the field of military art. Elizabeth Shoumatoff's portrait of Mrs. Brown, painted a number of years after her portrait of Mr. Brown, is a beautifully sensitive image of a remarkable woman. Her watercolor technique describes with skill Mrs. Brown's skin tones, lustrous hair, strands of pearls, and printed silk dress.

Elizabeth Shoumatoff

RUSSIAN, 1888–1980

68. *Nicholas Brown*, 1950

Watercolor on board, 11¼ by 10 inches

69. *Diane Vernes Brown (Mrs. Nicholas Brown)*, 1957

Watercolor on board, 11¼ by 10 inches

Collection of Captain and Mrs. Nicholas Brown

The portrait of the youthful Nicholas Brown, son of Mr. and Mrs. John Nicholas Brown, shares many qualities, including the casual sailing clothes and the indication of the sea in the background, with the watercolor of his father. The portrait of his wife, Diane Vernes Brown, painted seven years later, is much closer in tonality and texture to the watercolor of her mother-in-law.

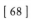

The Cushing Family

70. August Edouart

FRENCH, 1789–1861

Robert and John Gardiner Cushing, 1845

Silhouette, ink on paper
Cushing Family collection

Silhouettes became popular in America in the mid-nineteenth century. August Edouart was one of the first to practice this art on this side of the Atlantic. The French artist, who concentrated on this medium, had been silhouettist to the royal family of France. He eventually traveled to Ireland, Scotland, and America, to ply his trade. In 1845, he depicted the two Cushing boys at play in Boston. The inscription below the silhouettes indicates that the lad to the left is Robert M. Cushing, age six, and the one on the right, John Gardiner Cushing, age seven and a half. A grown Robert Cushing would come to Newport in the late 1850s and construct the family's summer home above Spouting Rock near Bailey's Beach. His great Victorian farmhouse became the setting of many paintings by his son, Howard Gardiner Cushing.

71. Henry Dexter

AMERICAN, 1806–1876

Mary Louisa Cushing, 1848

Marble, 22½ inches
Collection of the Newport Art Museum
Gift of Mrs. Reginald Norman

Mary Louisa Cushing (died 1894) was the sister of Robert, John, and Thomas Cushing. They were the children of John Peck Cushing, a suc-

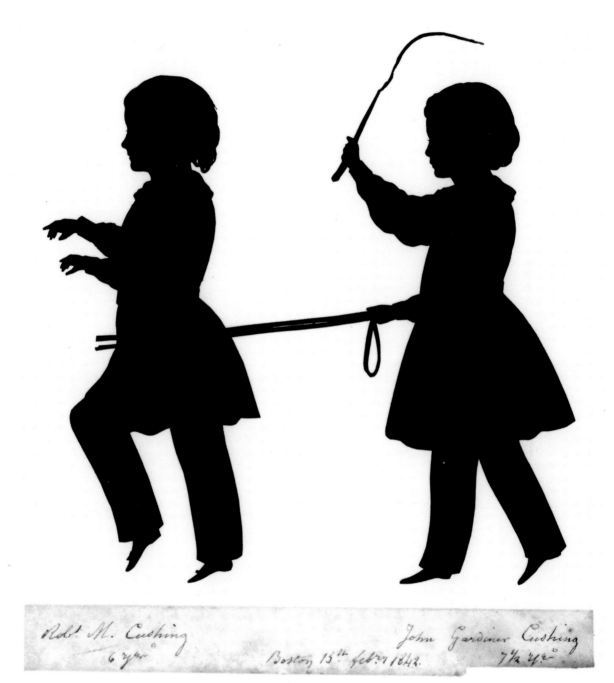

Robt. M. Cushing
6 yrs

Boston 15th febry 1842.

John Gardiner Cushing
7½ yrs

cessful Boston merchant who made his fortune in Asia. Their mother was Mary Louisa Gardiner, also of Boston. Sculpted in 1848, the image of the young child was one of a series of marble figures Henry Dexter made of the Cushing children. Henry Dexter signed and dated the work on the back of the base.

Marble sculpture was popular in mid-nineteenth-century America, and there was a particular interest in images of children. Here, the child, known to her family as "Isa" and aged three or four, sits on a cushion on the floor and reads a book. In 1864, Mary Louisa Cushing married painter Edward Darley Boit, and they built a home adjacent to that of her brother Robert above Spouting Rock in Newport. The Boit family returned on occasional summers to its Newport home but spent most of its time in France and Italy. Their house was lost in the 1938 hurricane: her brother's house still stands.

The youngest Boit daughter, the painter Julia Overing Boit (1877–1969) included this sculpture of her mother in a watercolor of the family's Paris apartment. Today, the piece is still set on the stand depicted in the painting. The sculpture was presented to the Newport Art Museum by Mrs. Reginald Norman, to whom Julia Overing Boit had given the piece. Mrs. Norman was the sister of Frances McCarty Little Boit, the second wife of Mary Louisa's husband and Julia's father, Edward Darley Boit.

72. Charles M. Newton

AMERICAN, NINETEENTH CENTURY

Mary Louisa Cushing Boit, 1883

Watercolor on paper, 12 by 10 inches
Collection of Mayor and Mrs. David S. Gordon

Mary Louisa Cushing Boit, posed informally seated on the ground in a landscape setting, is freely painted in watercolor. Charles M. Newton painted her after the birth of her four daughters and some twenty years after her marriage. The watercolor is initialed and dated on the lower right corner, and the artist and subject are identified on the back of the image. Newton studied in Paris and, along with Sargent, joined the studio of Carolus-Duran in 1874. Edward Darley Boit, Mary Louisa's husband, also studied in Paris at this time and was part of the same group of artists.

73. John Singer Sargent

AMERICAN, 1856–1925

Mary Louisa Cushing Boit (Mrs. Edward Darley Boit),
1887–1888

Oil on canvas, 60¼ by 42 inches
Gift of Miss Julia Overing Boit
Courtesy, Museum of Fine Arts, Boston

Edward Darley Boit was a close friend and colleague of John Singer Sargent. Their paths crossed frequently both in Boston and in Europe. The portrait of Mrs. Boit is one of three the artist painted of members of the Boit family. In Paris in 1882, he painted *Daughters of Edward Darley Boit* (Museum of Fine Arts, Boston). This portrait of Mrs. Boit was done in 1887 and 1888 in Boston. In 1908, Sargent painted a portrait of Edward Darley Boit himself.

In this painting, Sargent, viewing his subject from above, portrays Mrs. Boit seated on an elegant settee. She is dressed in black and pink polka-dotted satin and wears a black shawl, the textures of which are depicted with the skill for which Sargent was so widely known. This is a sensitive, warm portrayal of a person the artist knew well.

74. Howard Gardiner Cushing

AMERICAN, 1869–1916

Woman in White (Mrs. Howard Gardiner Cushing), 1905

Oil on canvas, 75 by 36 inches
Collection of the Newport Art Museum

Howard Gardiner Cushing was the son of Robert Cushing, who built a house above Spouting Rock in Newport. He was a graduate of Harvard and, following the example of numerous American painters, studied at the Académie Julian in Paris. Although he established the studio in New York City that would remain his headquarters, many of his canvases show that he summered in the family's Newport house.

In 1904, he married Ethel Cochrane of Boston. She became his favorite model, and this portrait was painted a year after their marriage. Ethel Cochrane Cushing was a great beauty, and the artist translated this onto all his canvases of her. This 1905 portrait reveals a certain Japanese flavor, perhaps reminiscent of Whistler's monochromatic paintings or of *ukiyo-e* prints. Ethel stands in a white gown in front of a white background and holds a Japanese fan.

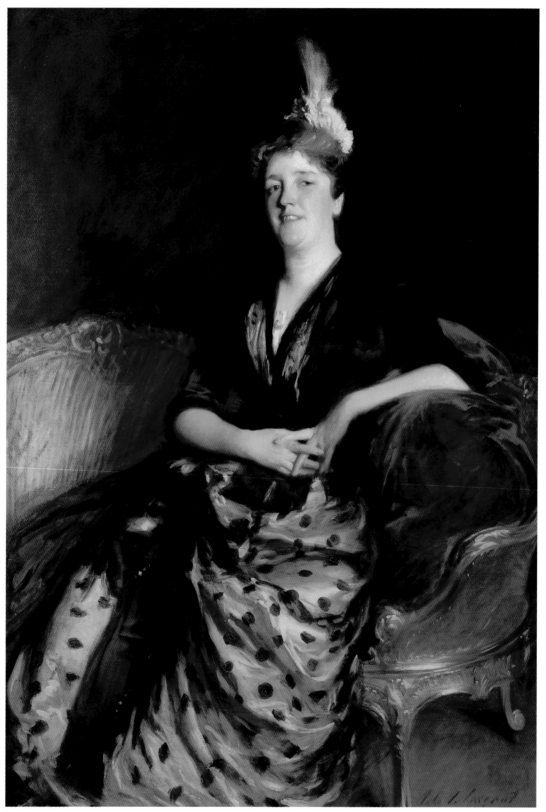

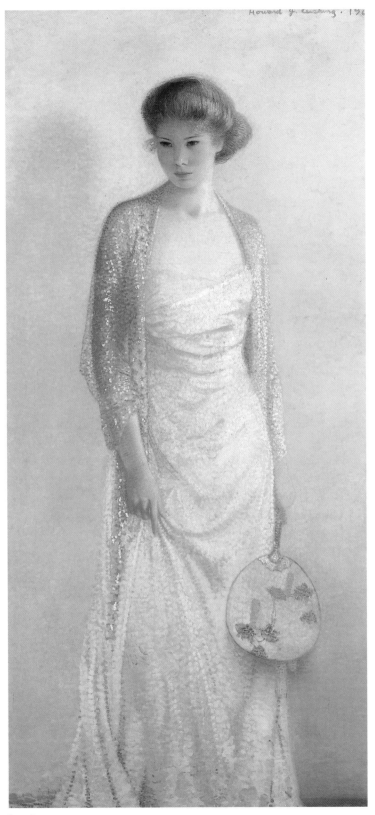

Ethel and Howard Gardiner Cushing were the parents of four children, whose families continue to summer in the great Newport farmhouse. In addition, Howard Gardiner Cushing was one of the original artist-members of the Art Association of Newport (now the Newport Art Museum), which was founded by Maud Howe Elliott in 1912. After Cushing's untimely death, a group of friends raised funds to erect the Newport Art Museum's Cushing Gallery in his memory. It is here that the Cushing paintings belonging to the Newport Art Museum are on display.

75. Howard Gardiner Cushing

AMERICAN, 1869–1916

Ethel Cochrane Cushing (Mrs. Howard Gardiner Cushing), about 1908

Oil on canvas, 60 by 49 inches
Cushing Family collection

The portrait of a seated Mrs. Cushing was a prize-winning painting. Ethel is posed on a settee, and her lowered head permits a fine display of her red hair. The pose is somewhat reminiscent of portraits by Sargent that view the subject from above (see cat. 73, Sargent's portrait of Howard Cushing's aunt, Mary Louisa Cushing Boit). This painting has a limited range of colors, emphasizing the range of whites in the subject's lustrous satin gown. This painting, perhaps more a study in tones than a portrait, fits into the popular tradition of American Impressionism.

76. Howard Gardiner Cushing

AMERICAN, 1869–1916

Interior with Mother and Child, about 1908

Oil on canvas, 30 by 25 inches
Collection of the Newport Art Museum

The painting is one of a pair depicting Mrs. Cushing with her young son Howard Jr. The composition emphasizes the interior decor of the room with its stunning Asia-inspired mural of pine trees. Howard Cushing concentrated on such murals during the later part of his life and created

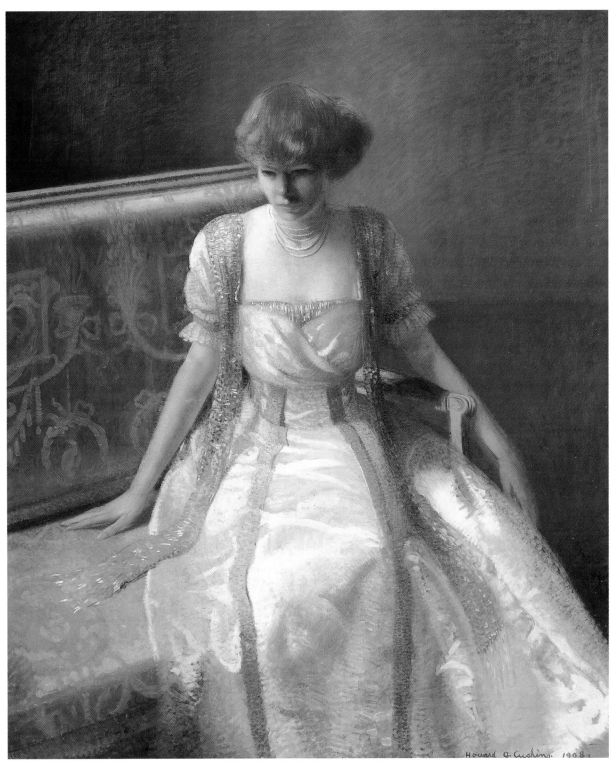

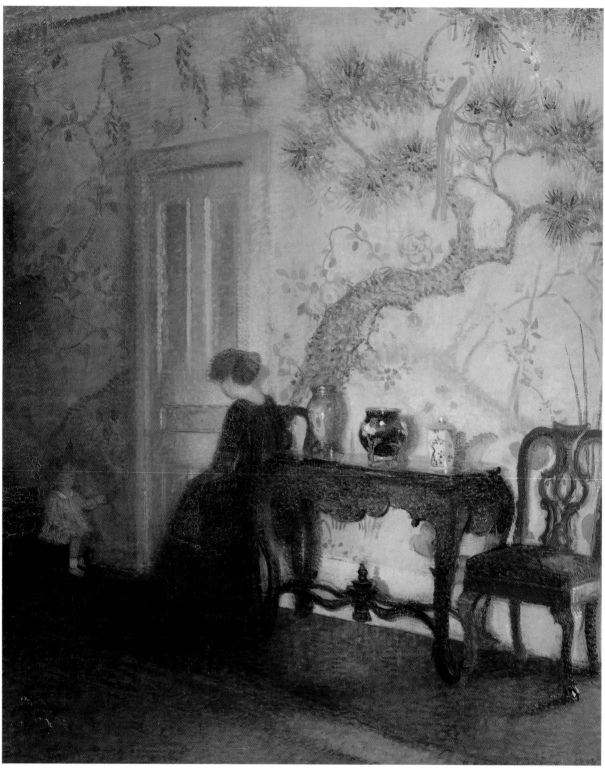

scenes inspired by Chinese images, even though he never traveled to Asia. The Newport Art Museum's collection includes several of Cushing's decorative panels of this type.

77. Howard Gardiner Cushing

AMERICAN, 1869–1916

Interior with Child and Toy Duck, about 1908

Oil on canvas, 30 by 25 inches
Collection of the Newport Art Museum

This interior scene showing Cushing's designs on the walls of his Newport house portrays young Howard Jr. standing in a room or hallway; his mother watches him from a second room. Ethel Cushing is immediately recognizable by her brilliant red hair.

78. Howard Gardiner Cushing

AMERICAN, 1869–1916

Mrs. Cushing and Her Sister Ann (The Blue Porch), 1908

Oil on canvas, 48 by 36 inches
Collection of the Newport Art Museum

Ethel Cushing is recognizable once again by her mass of red hair, here partly covered by a dark hat. She sits on the railing of the porch of the family home in Newport. Her sister Ann sits on chair and wears a Chinese robe. The corner of the porch with the view of Ocean Drive beyond still exists as Cushing depicted it. Today, the entire farmhouse is painted white, but the basic view and location are the same. The blue hydrangeas in the foreground give the painting a sense of stability and indicate the look of summer in Newport.

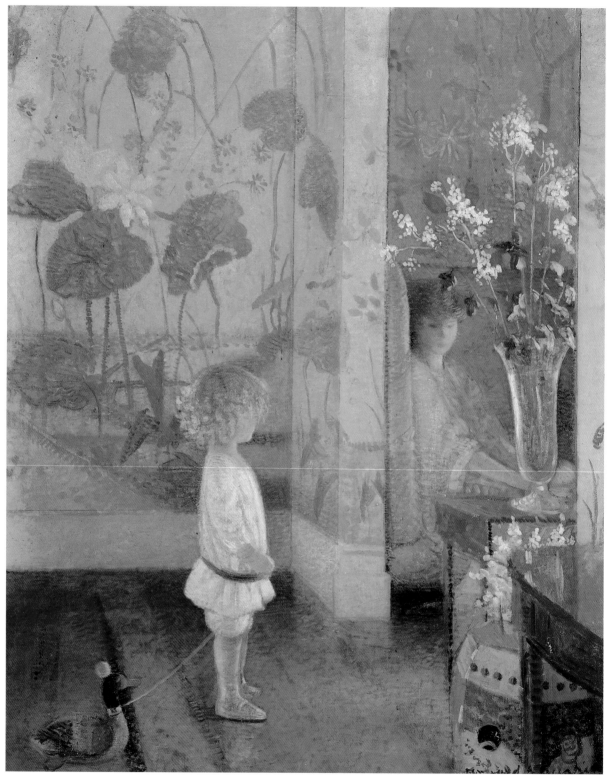

Elizabeth Shoumatoff

RUSSIAN, 1888–1980

79. *Howard Gardiner Cushing Jr.*, 1939

Watercolor on board, approximately 11 by 10 inches

80. *Mary Cushing*, 1939

Watercolor on board, approximately 11 by 10 inches
Cushing Family collection

Elizabeth Shoumatoff was in Newport on several occasions between the mid-1930s and the 1960s. She painted a number of prominent members of Newport's summer colony, including members of John Nicholas Brown's and Peter McBean's families.

Howard Gardiner Cushing Jr., depicted here in 1939, is the son of the painter and is the small child portrayed in two interior scenes. The companion piece is of his wife, Mary. These watercolors are meticulously painted in a rather dry-brush technique, which gives us almost photographic images of the sitters.

81. **Elizabeth Shoumatoff**

RUSSIAN, 1888–1980

Minnie Cushing

Watercolor on board, approximately 11 by 10 inches
Cushing Family collection

Minnie Cushing is the granddaughter of the painter Howard Gardiner Cushing. Elizabeth Shoumatoff used her typical, precise techniques to describe the young woman. Recently, Minnie Cushing Coleman and her husband, James J. Coleman Jr., were honored by the Newport Art Museum, which renamed its eighty-six-year-old art school the Minnie and Jimmy Coleman Center for Creative Studies.

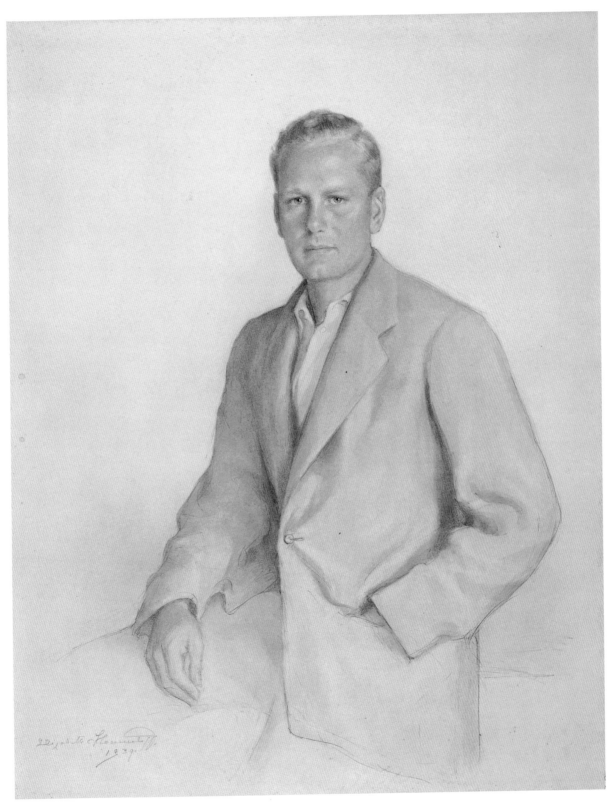

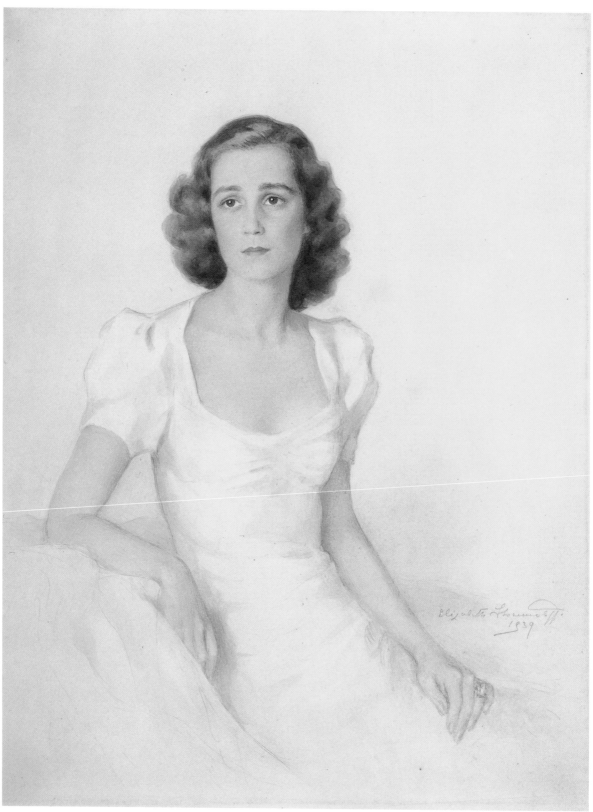

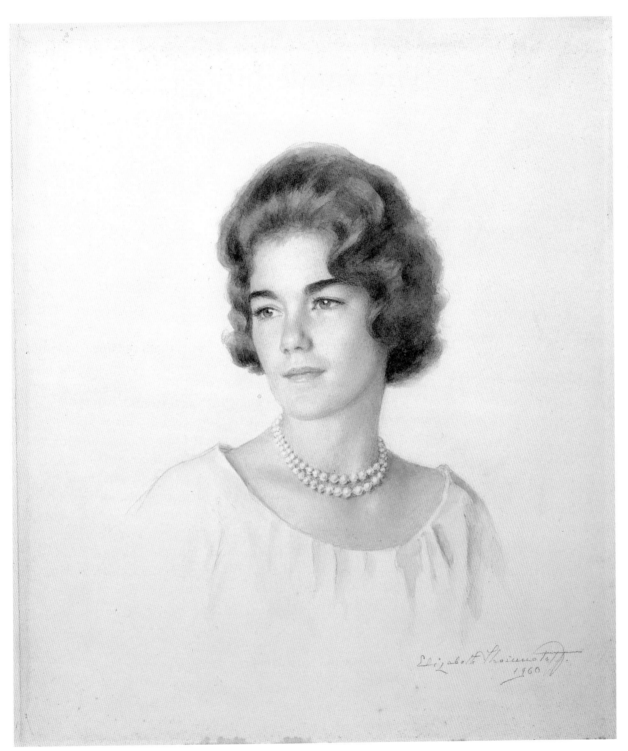

Elizabeth Shoumatoff
1960

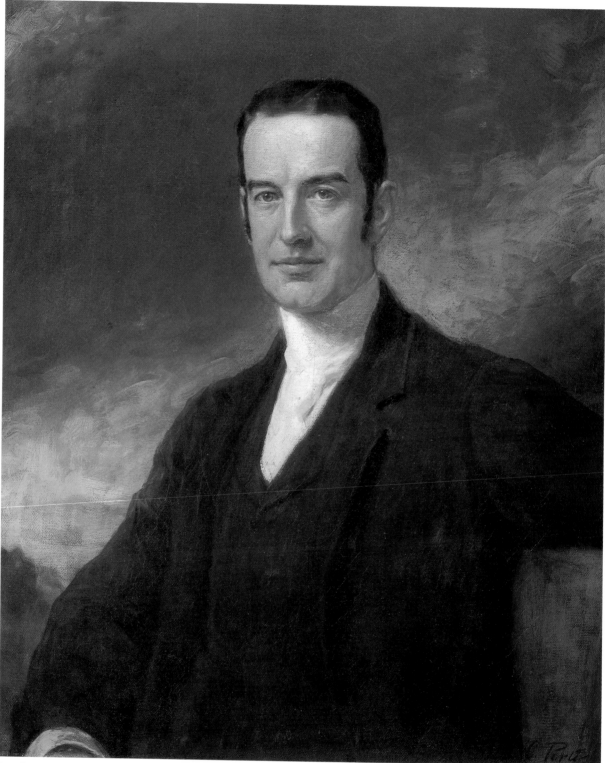

This portrait is one of two portraits of Cornelius Vanderbilt II that Benjamin Porter painted in 1899, the year of Vanderbilt's death. This portrait is the somewhat smaller version; the larger one, in the manner of eighteenth-century portraits, has Vanderbilt seated at his desk with the tools of his trade, papers and an inkwell.

Benjamin Porter was a Boston portrait painter who had studied in Paris. He exhibited in a number of Paris exhibitions and earned medals in the first years of the twentieth century. Porter also painted Maud Howe Elliott (see cat. 1) and members of the Cushing family.

84. Unknown artist

AMERICAN, NINETEENTH CENTURY

Cornelius Vanderbilt II, about 1890

Watercolor on ivory, 4¼ by 3¼ inches
Collection of the Estate of Countess Anthony Szápáry

The portrait in this miniature painting in an elaborate gilt frame is similar to the image of Cornelius Vanderbilt by Daniel Huntington. All three of our Cornelius Vanderbilt portraits show him in somber garb with his strong features emphasized by dark hair and brows. Alice Claypoole Gwynne married Cornelius in 1867. They had seven children; portraits of four are included in *Newportraits*.

85. John Quincy Adams Ward

AMERICAN, 1830–1910

William Henry Vanderbilt II, 1894

Marble, 38 by 13 inches on pedestal
Collection of the Estate of Countess Anthony Szápáry

William Henry was the second son of Cornelius and Alice Vanderbilt. He died while he was a student at Yale University in 1892. This posthumous bust was sculpted by John Quincy Adams Ward, a prominent artist who created numerous images of important Americans of his time, including Oliver Hazard Perry and Matthew Perry, whose bronze statues are today displayed in public parks in Newport. The marble bust of William is presented in the traditional neoclassical style, with the nude torso set on a base inscribed with the names or initials and dates of the subject and sculptor.

86. Raimundo de Madrazo y Garreta

SPANISH, 1841–1920

Gertrude Vanderbilt, Aged Five, 1880

Oil on canvas, 58 by 40 inches
On Loan to The Preservation Society of Newport County from the Estate
of Countess Anthony Szápáry

Gertrude (1875–1942) was the third child of Cornelius Vanderbilt II. She became an artist and an important patron of American modernism, and was also the future Mrs. Harry Payne Whitney. For this portrait, in the custom of the late nineteenth century, her family turned to a European painter. Raimundo de Madrazo y Garreta, from Spain, also painted Gertrude's mother the same year. He was known for his fashionable portraits, which gave prominence to the textures of the subject's gowns, as well as to the accessories of the setting. Note here the charmingly posed Gertrude and the luster of the pillows and upholstery, as well as the texture of the child's satin sash.

87. Gertrude Vanderbilt Whitney

AMERICAN, 1875–1942

Gladys Moore Vanderbilt, about 1890

Pencil and ink on paper, 12 by 8¾ inches
Collection of the Estate of Countess Anthony Szápáry

Gertrude did this informal sketch of her young sister, Gladys (1886–1965). The subject is identified, and the work is signed but not dated. Gertrude was some eleven years older than Gladys, who here appears to be three or four. Gertrude, of course, would become an important sculptor and patron of contemporary American art.

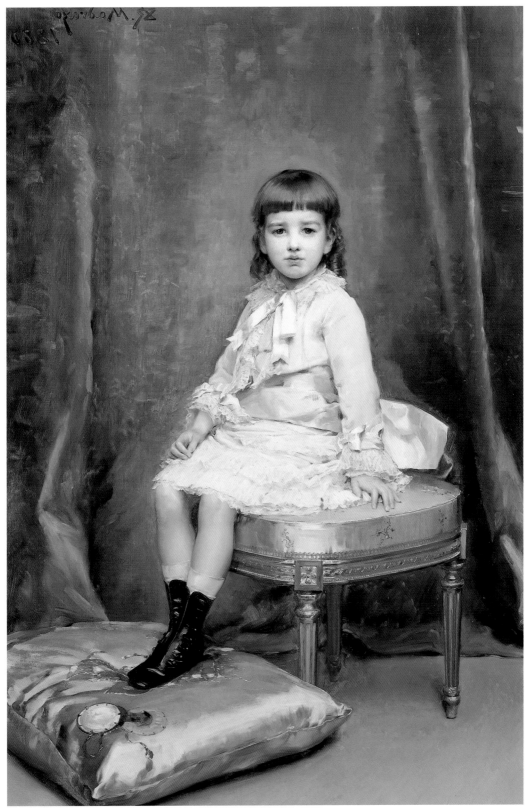

89. Rosina Montovanni Gutti

ITALIAN, LATE NINETEENTH CENTURY

Gladys Moore Vanderbilt, 1906

Pastel and charcoal on paper, 31 by 26 inches
Collection of the Estate of Countess Anthony Szápáry

Rosina Montovanni Gutti worked primarily in pastels and specialized in portraits of children. She did a portrait of Alice Vanderbilt in 1905, the same year she did this one of Gladys, Alice's youngest daughter. The signed works were both executed in Paris. Rosina Gutti was the daughter of the Italian artist Allessandro Montovanni.

90. Paul-César Helleu

FRENCH, 1859–1927

Gertrude Vanderbilt, about 1895

Drypoint etching on paper, 22 by 13¼ inches
Collection of the Estate of Countess Anthony Szápáry

This portrait of Gertrude was done shortly before her marriage to Harry Payne Whitney. It was one of several that the artist did of the young Vanderbilt women (see cat. 91 & 92). Helleu was a pastelist, painter, and etcher. He established his fame with his portraits of beautiful women. He gave his subjects grace and style and used the expressive quality of the drypoint line to its fullest. He studied in France at the Ecole des Beaux Arts, and he was a close friend of the American artists Sargent and Whistler. He came to New York in 1906, 1912, and 1920. The portrait of Gertrude was therefore probably done in Paris, where the artist maintained his studio.

91. Paul-César Helleu

FRENCH, 1859–1927

Gladys Moore Vanderbilt, about 1905

Drypoint etching on paper, 22 by 13¼ inches
Collection of the Estate of Countess Anthony Szápáry

Helleu etched this portrait of Gertrude's youngest sister, Gladys, some ten years after he did Gertude's portrait. Gladys was about twenty years

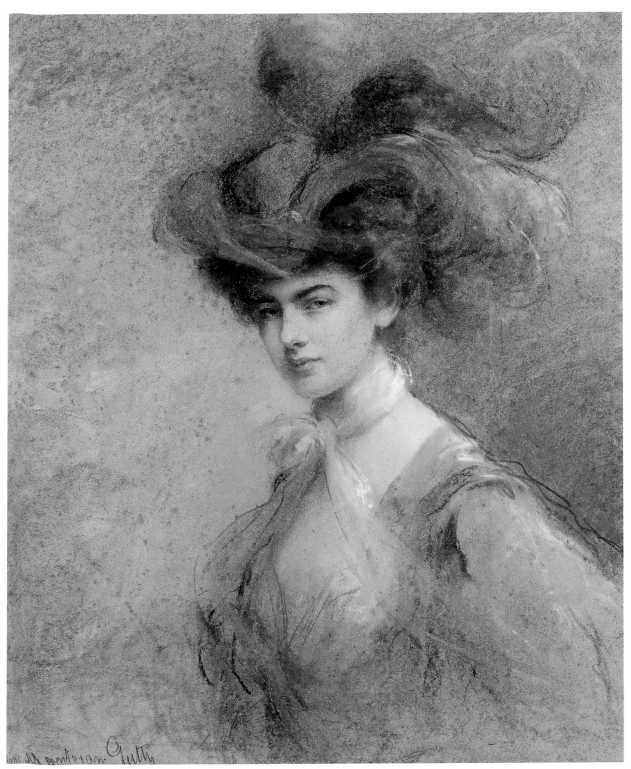

Countess Anthony Szápáry spent her summers in Newport until the time of her death in 1998. She resided in the top floor of The Breakers and took an active part in the governance of the Preservation Society of Newport County.

In his first version of this portrait, de László put Syvie in a yellow party dress. She objected to the garb and was eventually painted in her favorite outfit, her riding clothes.

99. Spy (Sir Leslie Ward)

ENGLISH, 1851–1922

Alfred Gwynne Vanderbilt, 1907

Ink and watercolor on paper, 14¼ by 9½ inches
Collection of the Estate of Countess Anthony Szápáry

"Spy" was the pseudonym of Sir Leslie Ward, a British cartoonist who made his name with satiric images of the well-born in *Vanity Fair* and *Punch*. This image of Alfred Gwynne Vanderbilt appeared in the July 31, 1907, issue of *Vanity Fair* in a series entitled "Men of the Day." Mr. Vanderbilt is elegantly dressed in top hat and morning coat, and carries gloves in one hand and a whip in the other as he prepares to take out one of his coaches.

Alfred Gwynne Vanderbilt (1877–1915) was the fifth child of Mr. and Mrs. Cornelius Vanderbilt II. A graduate of Yale University, he was known for his horsemanship. In 1909, he was a founding member of the Coaching Club of New York, and he drove numerous coaches in both America and England. He was praised for his skill with the whip, and one is thus included in the Spy drawing. Alfred Gwynne Vanderbilt lived at Oakland Park in Portsmouth, Rhode Island, where he kept his horses and coaches. He died in the sinking of the *Lusitania* in 1915.

100. Olive Snell

AMERICAN, EARLY TWENTIETH CENTURY

Cathleen Vanderbilt (Mrs. Harry Cooke Cushing III), 1925

Charcoal, graphite, and watercolor on paper, 20 by 14 inches
Private collection

Cathleen Vanderbilt (1904–1944) was the daughter of Reginald Claypoole Vanderbilt, the sixth child of Cornelius II and Alice Claypoole

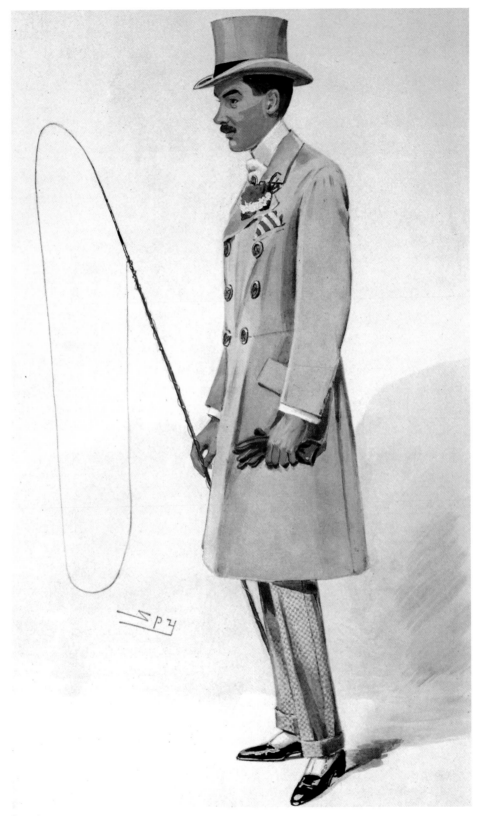

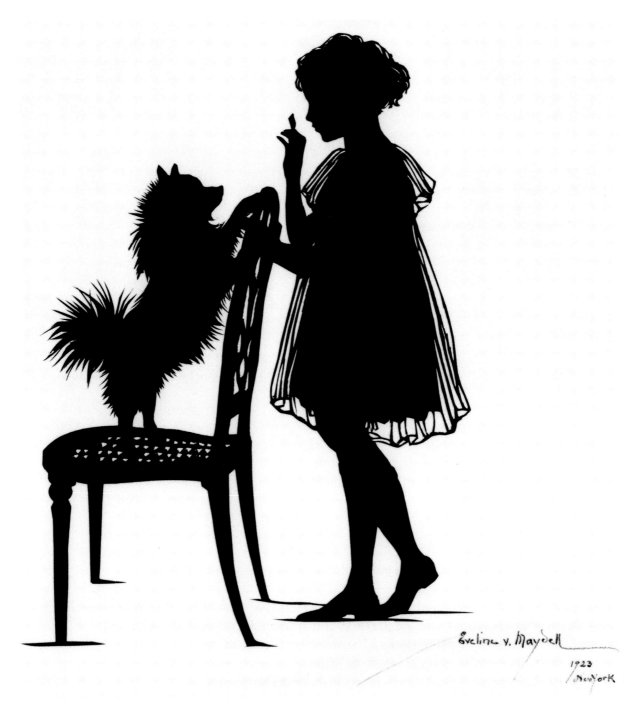

Eveline v. Maydell
1923
New York

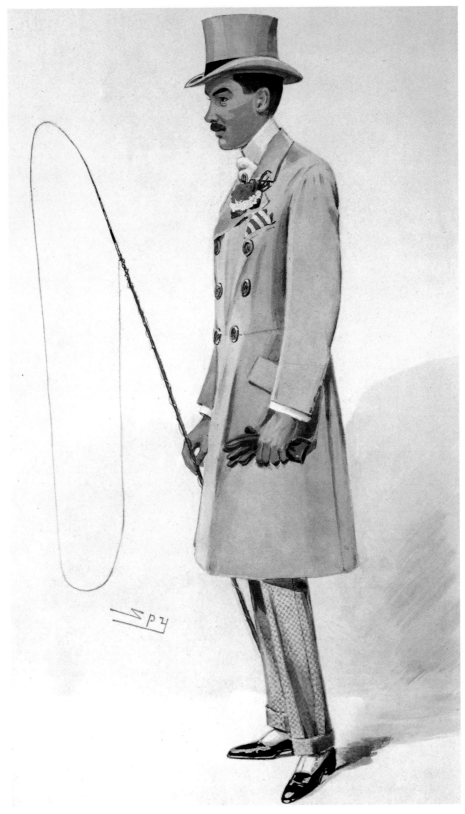

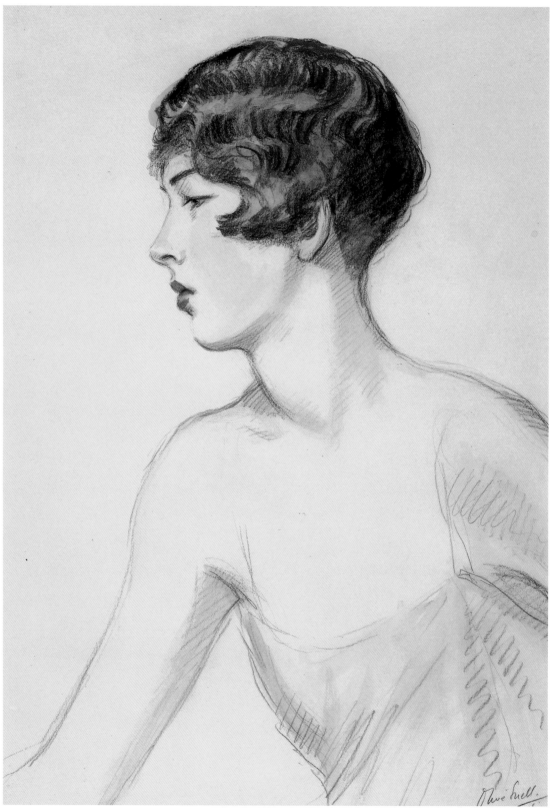

Vanderbilt. Cathleen's mother, Cathleen Gebhard Neilson, was Reginald's first wife. The family lived in New York City and had a summer home in Portsmouth, Rhode Island. Cathleen married Harry Cooke Cushing III, a New York stockbroker, in 1923, shortly before this drawing was executed. She was known for her exotic beauty and style and here is coifed in true flapper style. Her marriage to Harry ended in divorce in 1932. Harry Cooke Cushing IV, who now owns this piece, was their only child.

101. Emil Fuchs

AUSTRIAN, 1866–1929

Cathleen Vanderbilt (Mrs. Harry Cooke Cushing III), about 1925

Etching on paper, 13½ by 10¼ inches
Private collection

This etching of Mrs. Cushing was probably produced the same year as the Snell drawing, about a year after her marriage. The young woman is seductively posed, almost a fashion plate. The artist has dramatically emphasized her slanted eyes, "Clara Bow" lips, and bare shoulders.

102. William von Dresser

AMERICAN

Harold Stirling Vanderbilt, 1926

Charcoal on paper, 32 by 24 inches
Collection of The Preservation Society of Newport County

This charcoal drawing, signed and dated by William von Dresser, depicts Harold Vanderbilt, son of William K. and Alva Vanderbilt of Marble House. Harold (1884–1970) was an avid yachtsman who successfully defended the America's Cup three times in Newport and won numerous other trophies. Harold sold Marble House in 1932 after his mother's death. Von Dresser made several drawings of Newport's summer residents in the 1920s.

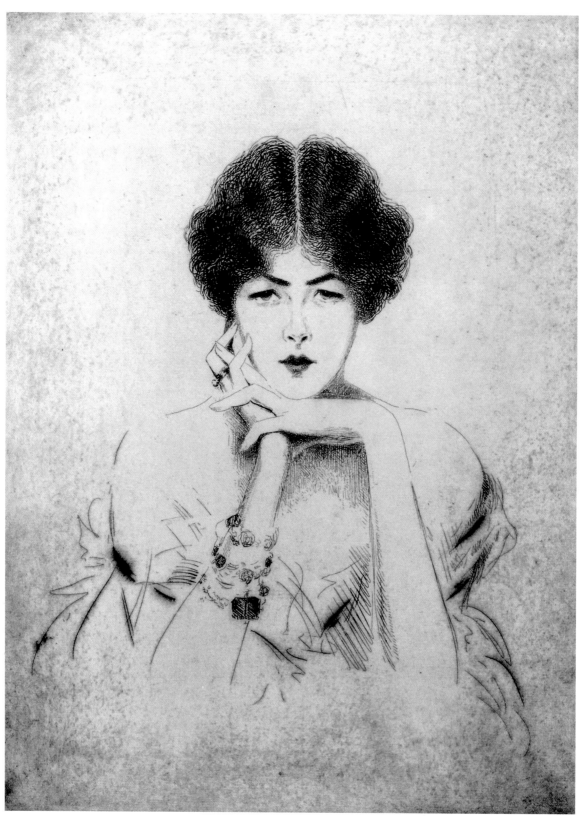

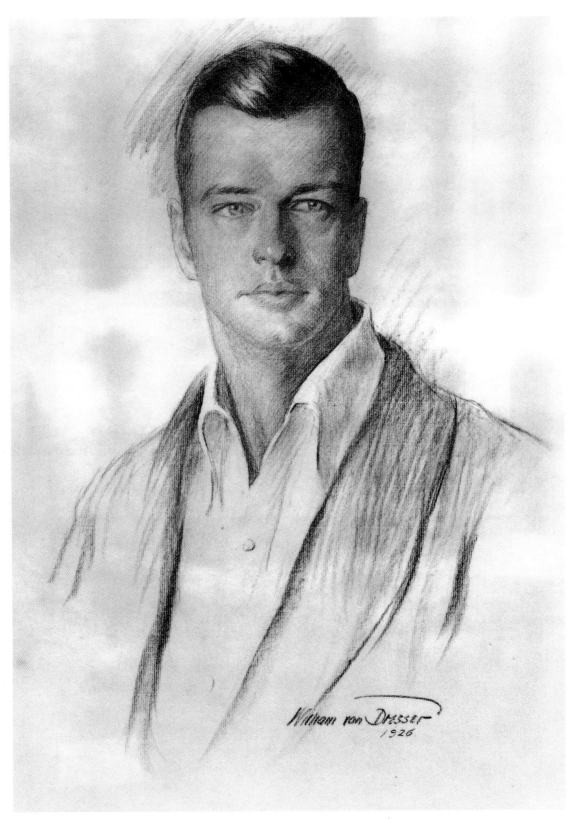

William von Dresser
1926

The Morris Family

103. Charles Cromwell Ingham

IRISH-AMERICAN, 1796–1863

Eliza Mier Lorillard (Bailey), 1839

Oil on canvas
Private collection

Charles Ingham was born in Dublin and died in New York City. The portrait of the young Eliza Mier Lorillard shows her posed in a landscape that includes the family home on the Hudson. Her hair is smooth and parted in the center, the style for a young girl. She is tightly corseted under her white dress. The red paisley shawl reflects the fashion of the times (see cat. 23, the portrait of Mrs. Ellery by Henry Cheever Pratt).

Eliza married Nathaniel Platt Bailey, and her sister Emily married a Morris. Both the Bailey and Morris names reappear in this collection in portraits of their descendants, members of Newport's summer colony.

104. Unknown artist

AMERICAN

Mrs. Henry Bedloe (Josephine M. Homer), 1873

Oil on canvas
Private collection

This small canvas, a typical nineteenth-century sporting picture, represents Mrs. Bedloe on horseback. She is accompanied by a white hound. Mrs. Bedloe was the mother of Harriet Hall Bedloe Morris.

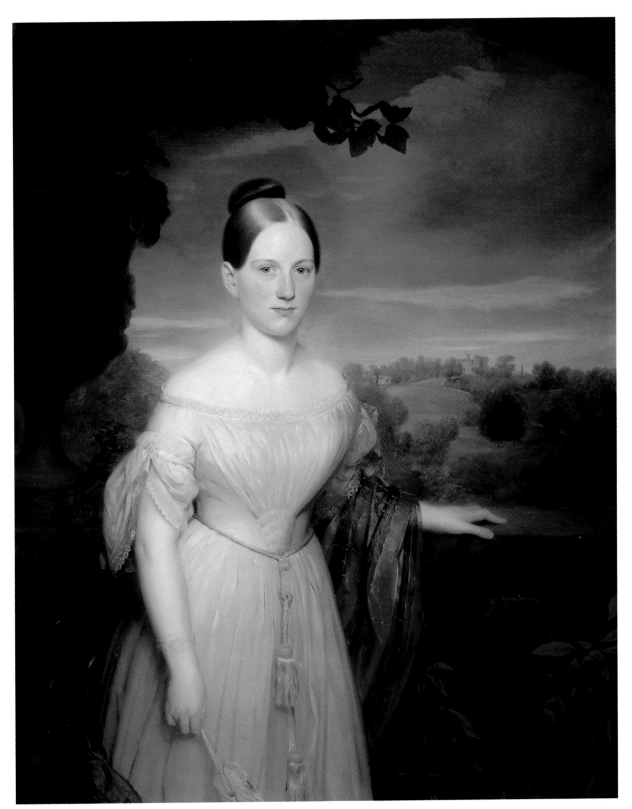

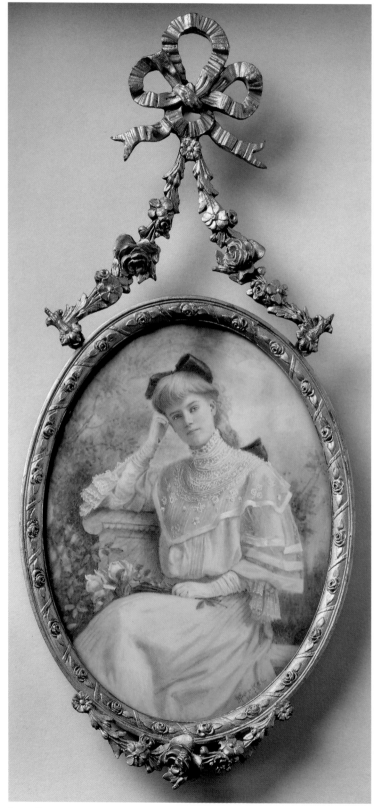

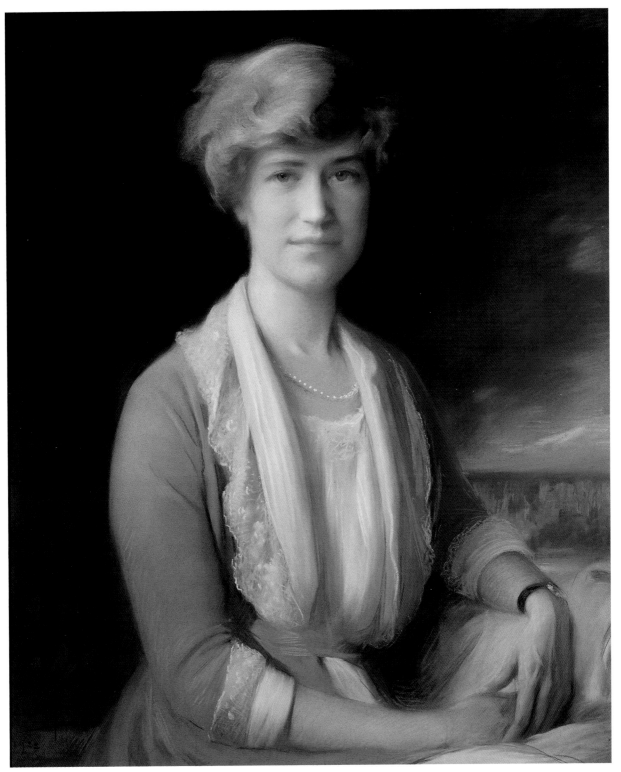

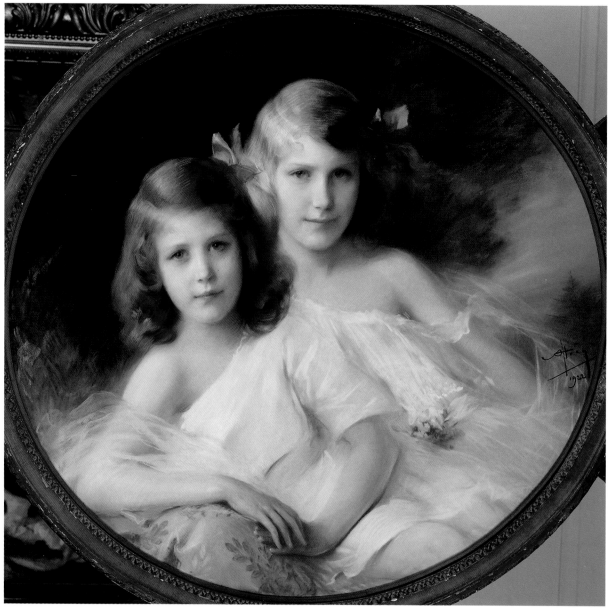

108. Unknown artist

AMERICAN (?)

Betty Morris, 1920

Watercolor on ivory, 13½ by 16⅜ inches (framed)
Private collection

Elizabeth Morris (Betty) appears in a number of works in this collection. This work portrays her at a slightly younger age than the double portrait by Hoen (cat. 107).

109. Eveline von Meydell

ESTONIAN, 1890–1962

The Morris Family, 1926

Paper silhouette on paper with pencil, 29½ by 21 inches (framed)
Private collection

Alletta Nathalie Bailey Morris and her husband, Lewis Gouverneur Morris, are seated with their Newport home, Malbone House, in the background. They are flanked by their two daughters. The younger one, Betty, is on the left; she holds the family cat. Alletta, the older daughter, is on the right with the dog Flicka. She is dressed in a sophisticated outfit with her hair bobbed in the style of the 1920s. The family group is surrounded by the intricately cut framework of a trellis with leaves and lanterns. Baroness Eveline von Meydell was highly skilled in the art of silhouette making. She made a number of trips to Newport in the 1920s and 1930s and cut silhouettes for members of the Stonor and Gillespie families (see Brown family section, cat. 58 & 59), as well as the Morris family (cat. 110).

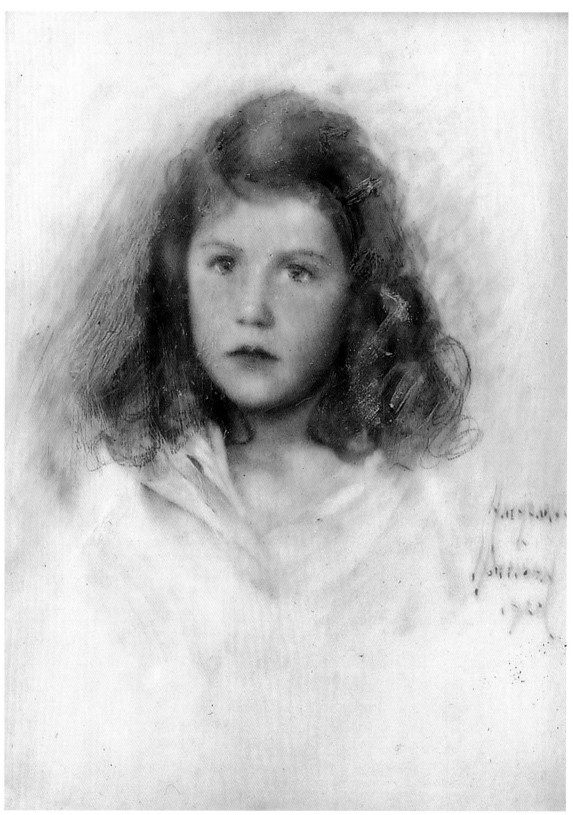

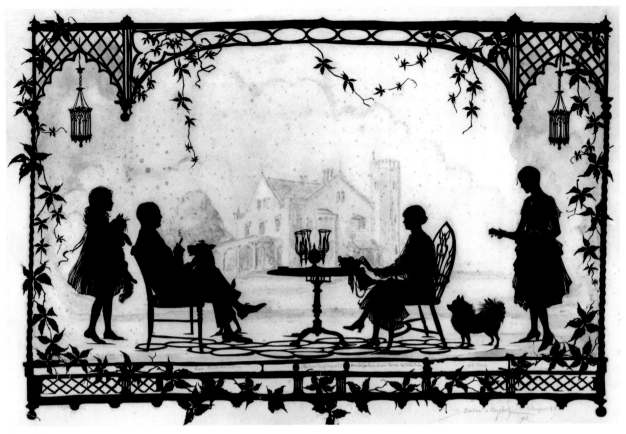

[109]

I IO. Eveline von Meydell

ESTONIAN, 1890–1962

Betty Morris and Flicka, 1923

Paper silhouette on paper, 7½ by 14 inches
Private collection

Young Betty, who also appears in the previous two works (cat. 107 &
108), is alone here with her dog Flicka. The intricate cutting of the
paper for this silhouette is again astonishing. This piece is inscribed
"New York." This image was no doubt done a little later than the pre-
vious one; here Betty has a new, shorter haircut.

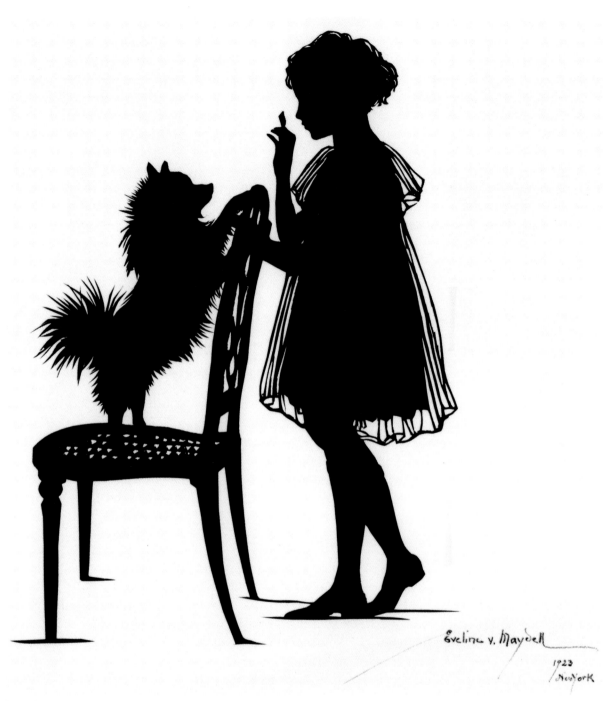

Eveline v. Maydell
1923
New York

[111]

I I I. Wood

AMERICAN

The Morris Family, about 1922

Pen and ink, 29½ by 21 inches (framed)
Private collection

This grouping of the Morris family was done by a silhouettist identified only as "Wood." The family is gathered in the sitting room of their New York house, a somewhat more formal setting than that at Malbone House in Newport. More figures are included here. Alletta and her parents, Mr. and Mrs. Morris, are to the left of the tea table. To the right, the seated grandmother is attended by the butler with a teacup and the maid with a shawl. Betty sits on the floor with two family pets. In the background, the 1839 portrait of Eliza Mier Lorillard (Bailey) by Charles Ingham (cat. 103) hangs over an elaborate mantelpiece. This entire silhouette is drawn with opaque India ink, washes, and pen and ink lines; it projects an image different from von Meydell's cut silhouettes.

[112]

112. Elizabeth Shoumatoff

RUSSIAN, 1888–1980

Alletta Morris McBean (Mrs. Peter McBean), about 1936

Watercolor on paper, 14 inches in diameter (round)
Private collection

Elizabeth Shoumatoff painted Alletta Morris McBean with the same clarity evident in the artist's other portraits (see Brown and Cushing Families, cat. 66–69 & 79–81). Here, Alletta is a mature and glamorous young society matron of the mid-1930s.

Portraits on Paper

I I 3. **John La Farge**

AMERICAN, 1835–1910

John Chandler Bancroft, 1863

Graphite on paper, 8 by 5¾ inches
Collection of the Redwood Library and Athenaeum, Newport, Rhode Island
Bequest of Frances S. Childs (granddaughter of the artist), 1989

John La Farge came to Newport in 1859 to study with William Morris Hunt at his studio on Church Street; he had studied previously in Paris with Thomas Couture. La Farge's friend John Bancroft, the subject of this drawing, arrived in Newport in 1863. It is said that Bancroft preferred to speak of art in French, a language he considered more appropriate to such discussions. Bancroft took up residence at Paradise Farm, La Farge's home in Middletown, Rhode Island. Together, they imported Japanese prints through a New York firm.

I I 4. **John La Farge**

AMERICAN, 1835–1910

Thomas Sergeant Perry Talking to Bancroft at Paradise Farm, 1865

Pencil on paper, 7¾ by 5¹⁄₁₆ inches
Collection of the Redwood Library and Athenaeum, Newport, Rhode Island
Bequest of Frances S. Childs (granddaughter of the artist), 1989

This drawing is stamped with La Farge's red Chinese seal and signed by the artist. An additional inscription notes the subject of the drawing, Thomas Perry's conversation with La Farge's friend Bancroft. Perry was

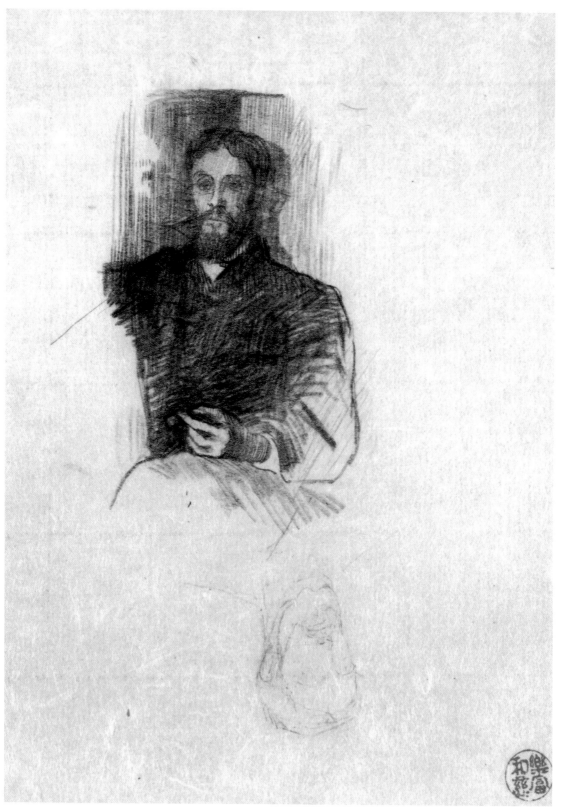

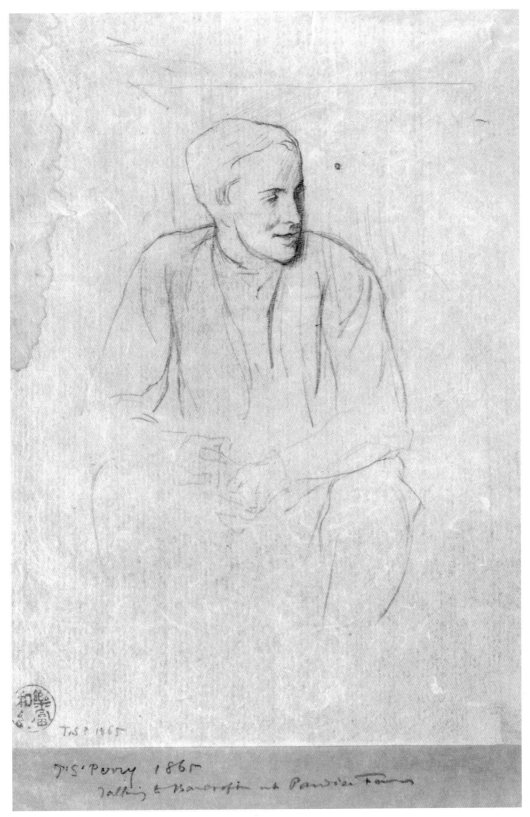

T.S. Perry 1865

T.S. Perry 1865
Talking to Bancroft ... Paradise Farms

the grandson of Commodore Oliver Hazard Perry and brother of Margaret Mason Perry, whom La Farge had married in 1860. Paradise Farm, at first the La Farge summer home, became their permanent residence in 1863. In addition to his painting, La Farge involved himself in the interior decoration of several Newport churches, including the stained glass and encaustic wall and ceiling painting at the United Congregational Church on Spring Street (1880) and the windows in Channing Memorial Church (1880) on Pelham Street.

I I 5. Paul-César Helleu

FRENCH, 1859–1927

Charlotte Warren Greenough, about 1900

Charcoal and red and white chalk on paper
Collection of Mr. and Mrs. George H. Warren

Helleu, documentor of beautiful American women, produced drawings as well as drypoint etchings (see Gertrude, Gladys, and Consuelo Vanderbilt, cat. 90, 91, & 93). This charmingly posed view of Charlotte Warren Greenough was done at the turn of the century.

I I 6. William Pretyman

AMERICAN

Walter Howe, 1885

Watercolor on paper, 22 by 19 inches
Collection of Mr. Bruce Howe and Dr. Calderon Howe

William Pretyman produced this watercolor of Walter Howe in 1885. Walter, part of the Newport community, owned a large, comfortable home on Hammersmith Road. Both of his grandsons are now residents of Newport for much of the year. Calderon is a physician married to a sister of the Drury girls (cat. 120 & 121, Hope Curtis Drury). Bruce Howe was for many years president of the Art Association of Newport.

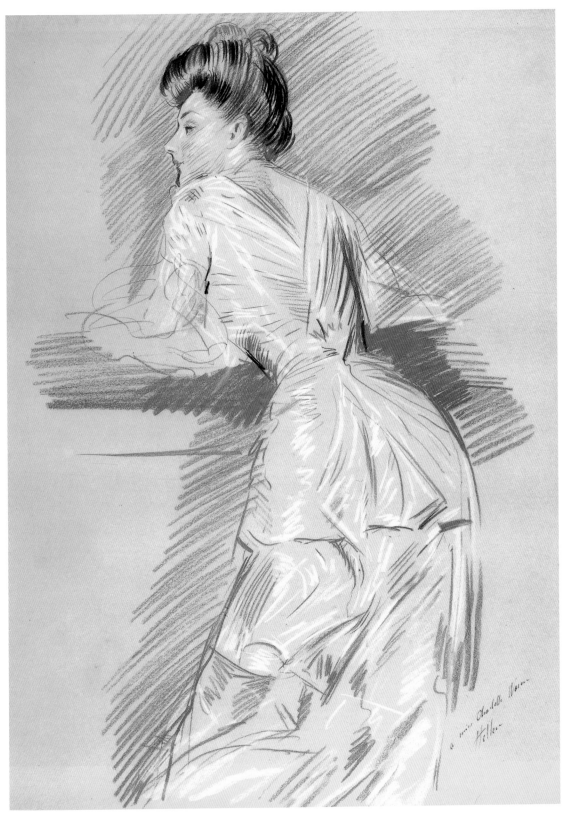

Hope Curtis Darrin

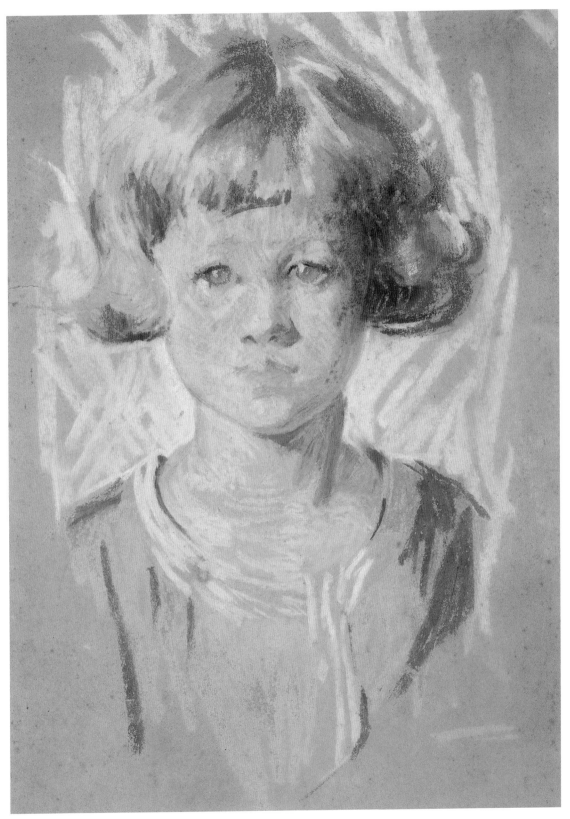

122. Jesse Voss Lewis

AMERICAN

Helen Michalis (Mrs. John G. Winslow), 1927

Pastel on paper, 26 by 22 inches
Collection of Mr. and Mrs. John G. Winslow

Drawings of children were particularly popular in the 1920s. They often caught the charm and youthfulness of the child. This drawing is signed and dated. Helen Winslow is an active member of Newport's cultural organizations and society. Her husband was a long-term and distinguished president of the Preservation Society of Newport County.

123. William von Dresser

AMERICAN

Elizabeth Blake, 1927

Charcoal and colored pencil on paper
Collection of Elizabeth B. Blake

William von Dresser did a portrait of Harold Vanderbilt (see cat. 102) at about the same time he did this drawing of young Betty Blake. It is signed and dated in pencil. Betty Blake has long been involved in the arts as a collector and patron. A trustee of the Newport Art Museum, she was one of the organizers of the exhibition *Newportraits*.

JESSIE VOSS LEWIS
1927

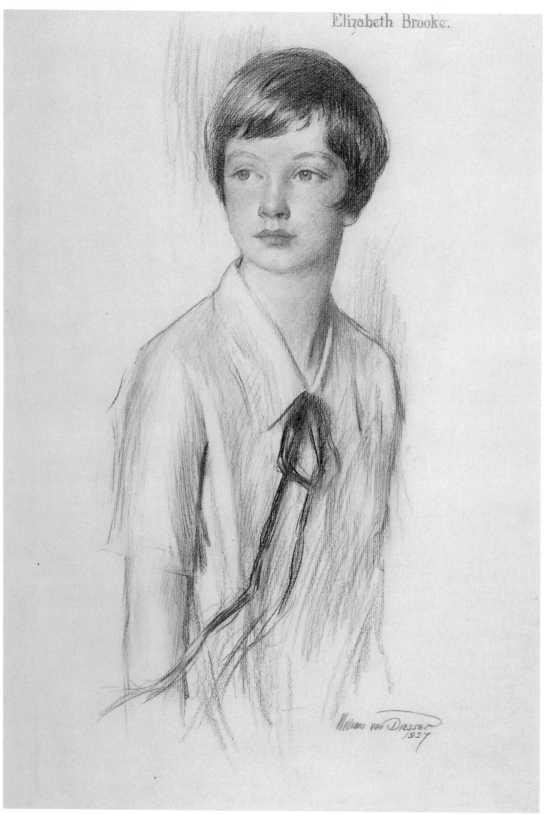

Elizabeth Brooke.

124. Frank O. Salisbury

ENGLISH, BORN 1874

Grenville Kane, 1927

Charcoal and white chalk on paper, 26 by 22 inches
Collection of Mr. and Mrs. John G. Winslow

This charcoal drawing is signed and dated and may indicate it is a study for a more finished portrait. A seated gentleman with a book in hand is a traditional formula for such portraits. Grenville Kane was a descendant of John Jacob Astor. He and his brothers were active in New York City society in the 1890s. They were known to drive four-in-hand carriages down Fifth Avenue and were part of Newport's great coaching tradition at the turn of the century.

125. Robert Hale Ives Gammell

AMERICAN, 1893–1981

William Lansing Hodgman, 1927

Pastel on paper, 25 by 19½ inches
Collection of Mrs. Richard G. Alexander

Robert H. I. Gammell was a member of the Boston school of painting and a pupil of John Paxton. Usually painting large historical panels and murals, he worked in Rhode Island as well as Boston. A series of murals on the history of Providence is still in a bank building on Westminster Street in Providence. Although Gammell lived in Providence, he summered in Newport. The three pastel drawings included here represent different generations of his family. He drew William in 1927; the work is inscribed to "Hope with a Merry Xmas from Ives 1927." Hope was his daughter, the wife of Theodore I. H. Powel; their daughter, also named Hope, now owns the drawing.

126. Robert Hale Ives Gammell

AMERICAN, 1893–1981

Bessie Gardner (Bowen) Gammell, 1937

Chalk and crayon on paper
Private collection

Bessie Gardner Gammell was the mother of the artist.

127. Robert Hale Ives Gammell

AMERICAN, 1893–1981

Hope Hodgman Powel Alexander, 1948

Pastel on paper, 25½ by 19½ inches
Collection of Mrs. Richard G. Alexander

Robert H. I. Gammell continued the tradition of realism established by the painters of the Boston school in the early part of the century. The conservative nature of his art ran counter to contemporary movements developing in America after World War II. This is evident in his narrative canvases as well as in his portraits, such as this one of Hope Hodgman Powel Alexander, the granddaughter of William Hodgman (cat. 125). This pastel was done just one year after Hope's marriage to Richard Alexander.

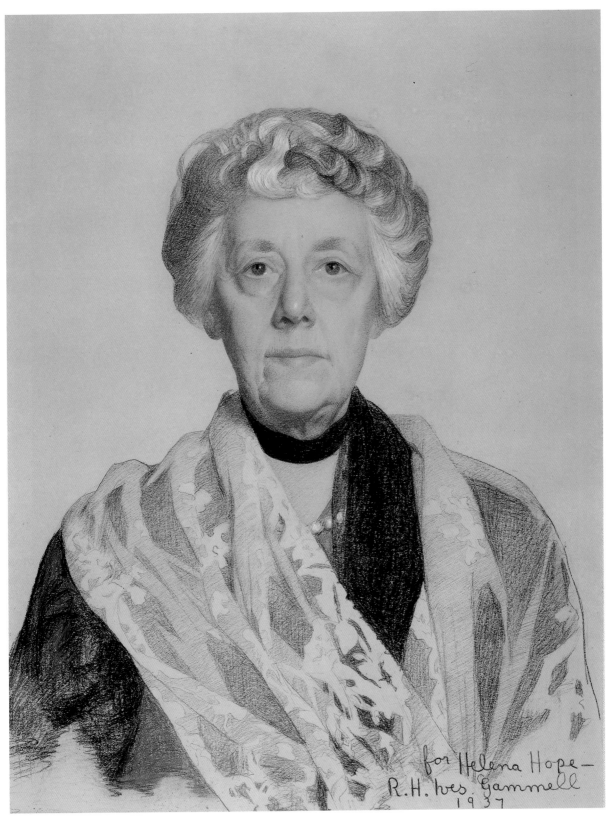

for Helena Hope—
R.H. Ives Gammell
1937

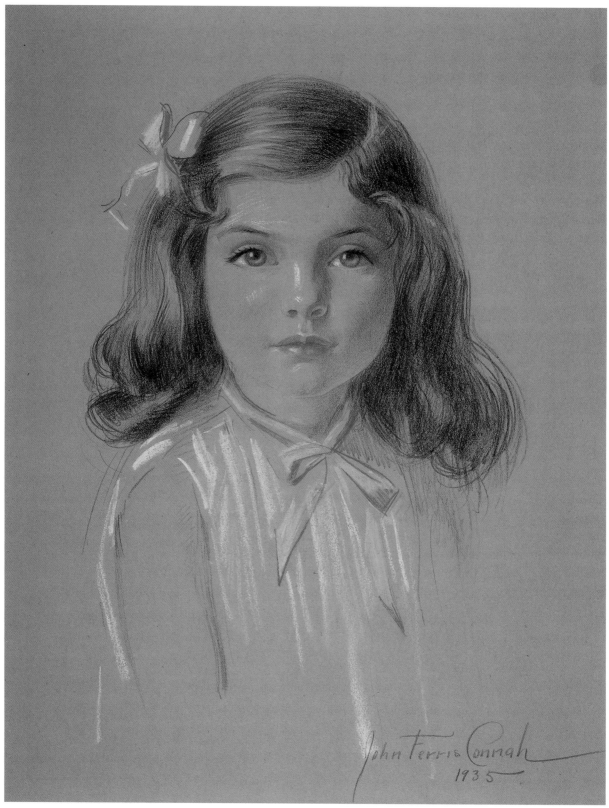

Eveline von Meydell

ESTONIAN, 1890–1962

131. *William Gammell Jr.*

Paper silhouette on paper

132. *Susan Valentine (Mitchell) Gammell*

Paper silhouette on paper
Private collection

Von Meydell has once again worked meticulously with her scissors in this pair of silhouettes, cut with great attention to detail. These are two more members of the Gammell family, a Rhode Island family with long roots in Providence and Newport. Mr. and Mrs. William Gammell Jr. sit in chairs set on a complicated parquet floor. Her chair is Chippendale; his, Greek Revival. William is joined by his dog.

133. **Eveline von Meydell**

ESTONIAN, 1890–1962

Hugh D. Auchincloss with His Dogs, 1932

Paper silhouette on paper with pencil
Collection of Hugh D. Auchincloss III

Eveline von Meydell has once again used her skill with scissors to create this charming composition of young Hugh flanked by his two large dogs. Hugh, or "Yusha" as he has always been called, sits on a high garden stool. The ground is a complicated decoupage of garden flowers. The background, drawn in pencil, is of Hammersmith Farm and its view of Jamestown.

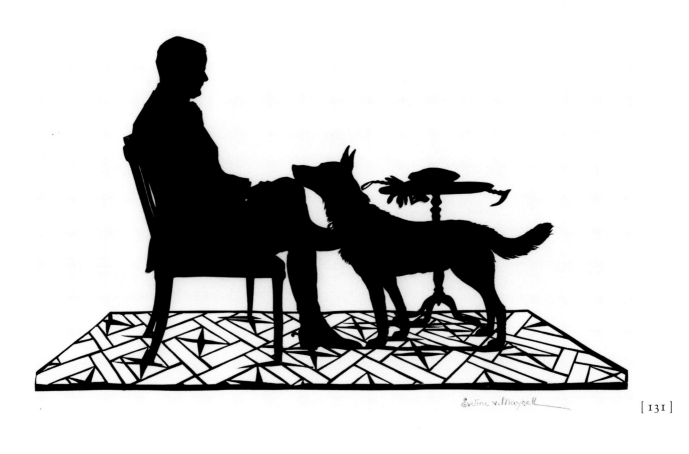

Eveline v. Maydell

[131]

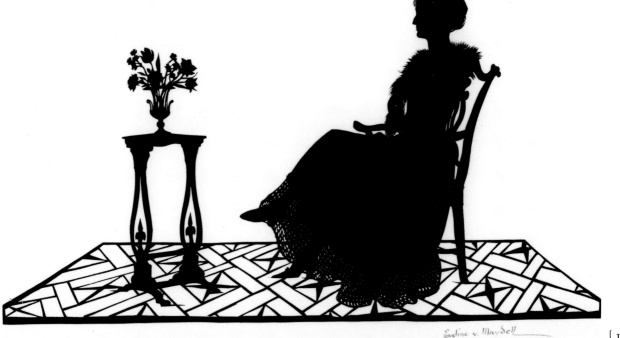

Eveline v. Maydell

[132]

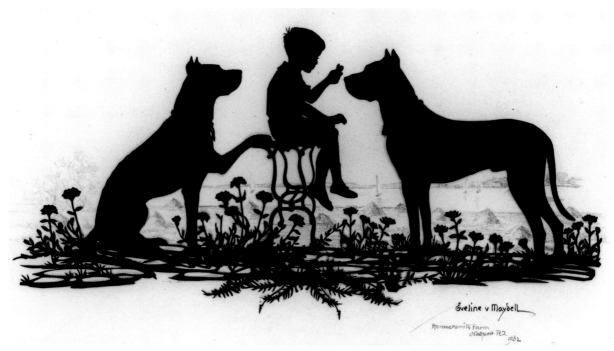

[133]

134. Holden D. Wetherbee

AMERICAN

William P. Sheffield III and Faithful Fritz, 1930

Paper silhouette on paper with ink
Collection of Richard B. Sheffield

Newport lawyer William P. Sheffield III is seated in a wing chair and attended by his dog, Faithful Fritz. The silhouette presents the casual image of a man, pipe in mouth, in his home. Wetherbee made his appearance when Eveline von Meydell was also making silhouettes; his are less detailed.

135. Holden D. Wetherbee

AMERICAN

Katherine, William and Stephen Spencer, 1930

Triple silhouette with ink on paper, 12 by 24 inches (framed)
Collection of Mr. and Mrs. Stephen Spencer

Each silhouette is mounted separately, but they are matted together on a single sheet. Katherine, the eldest, is on the left with her book; young William reaches for his toy horse; and Stephen, who now owns this piece, stands to the right with his toy bear. Wetherbee again presents conventional silhouettes without the intricate decoupage practiced by von Meydell.

136. Holden D. Wetherbee

AMERICAN

Stephen W. Spencer, 1930

Paper silhouette on paper with ink, 10 by 12 inches
Collection of Mr. and Mrs. Stephen Spencer

Young Stephen is shown on his tricycle. This silhouette was done at the same time as the triple portrait of the Spencer children (cat. 135). Today, Katherine and William, no doubt, have their images in their own collections.

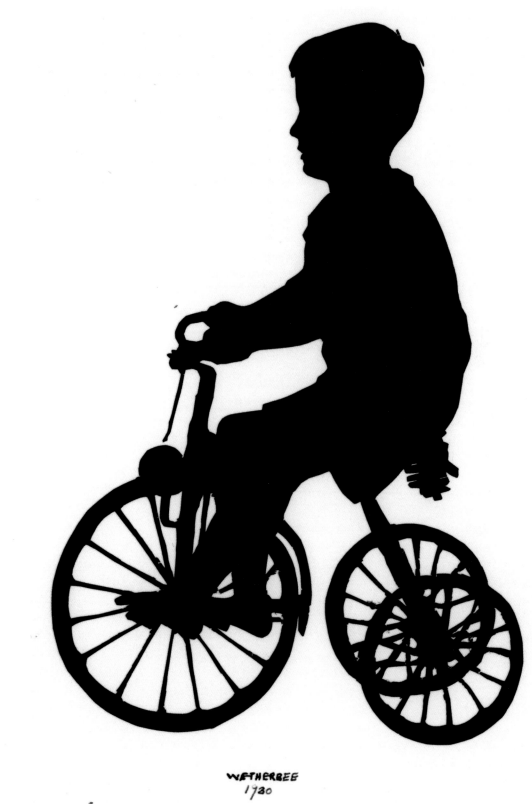

WETHERBEE
1930

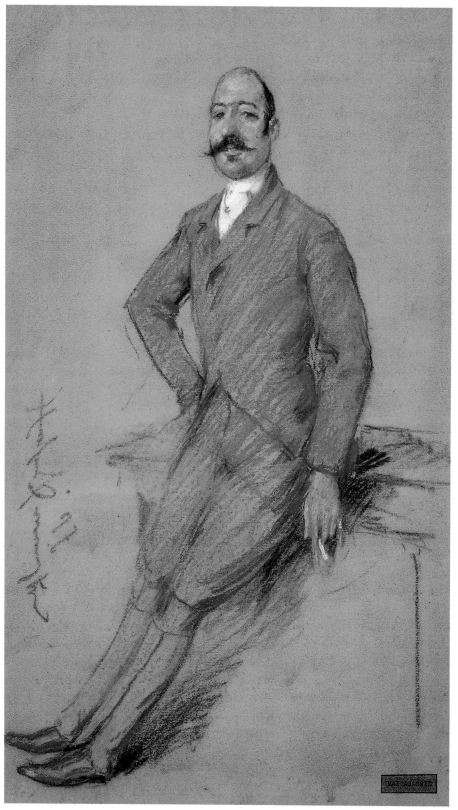

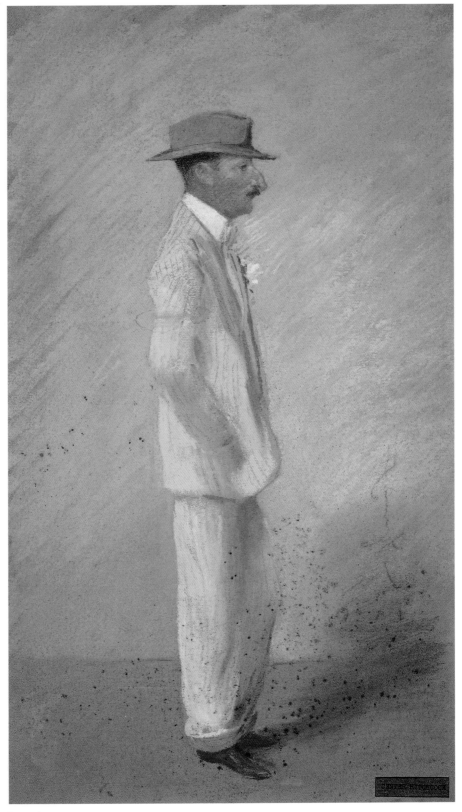

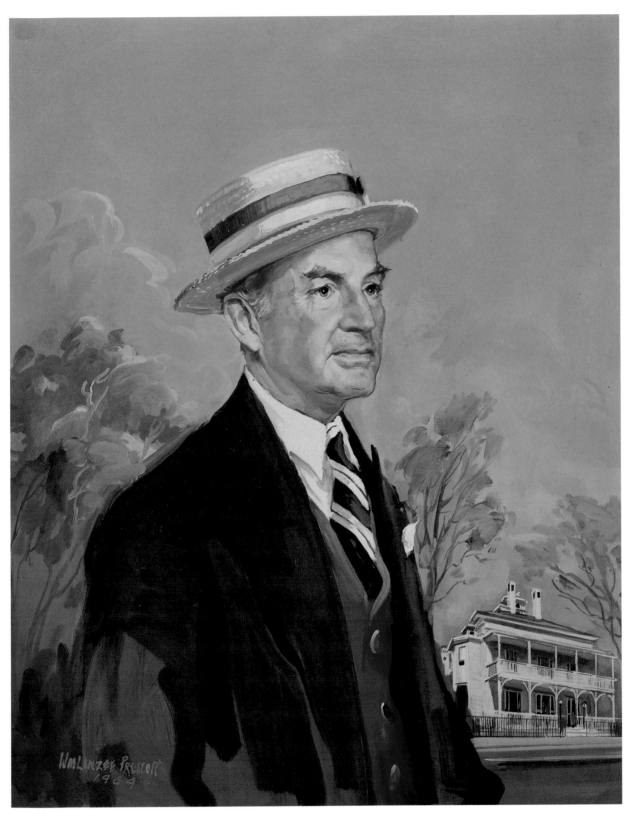

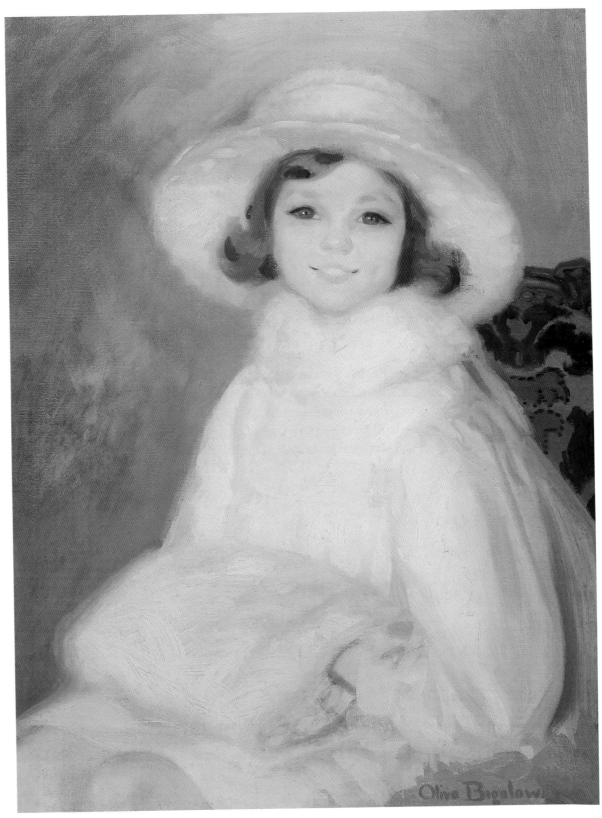

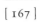

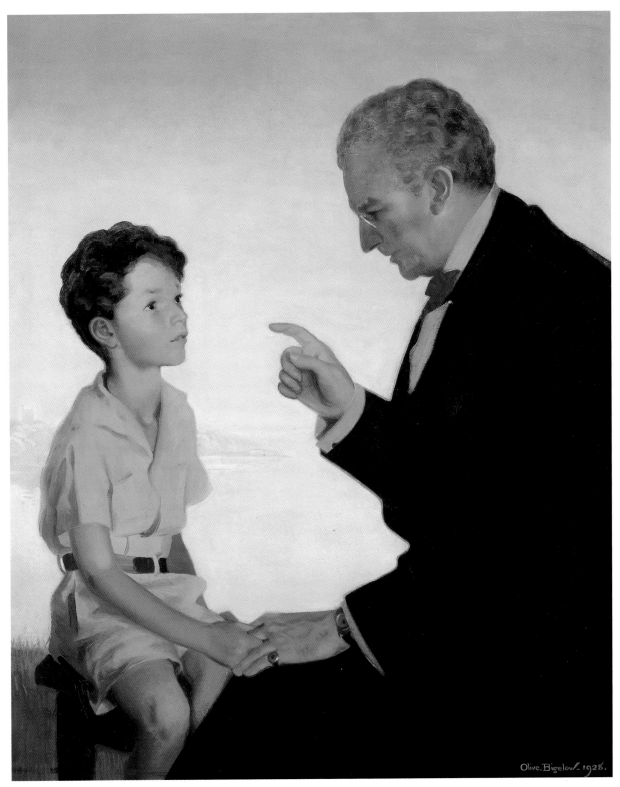

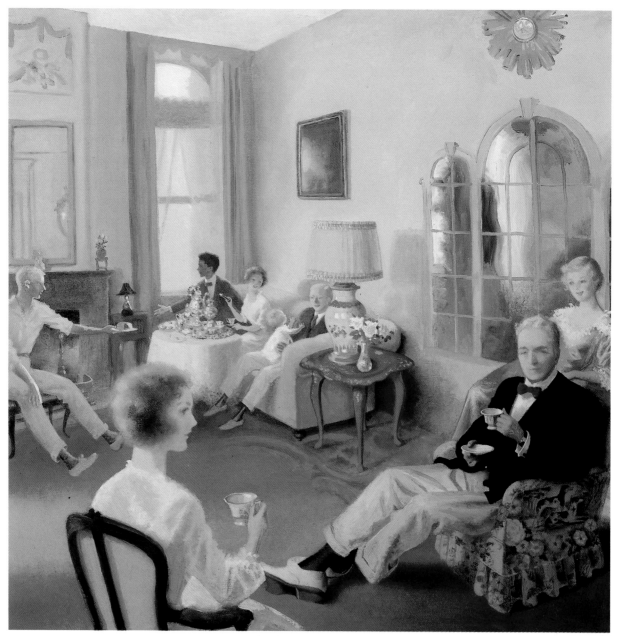

170. Olive Bigelow Pell

AMERICAN, 1886–1980

One Lump or Two? (Self Portrait)

Oil on canvas, 52 by 38 inches
Collection of John Holmsen Brainard

This joyous self-portrait was a family favorite. It shows the gracious Olive pouring tea for her family; she uses the same tea service depicted in the previous painting. Note the care with which the artist has painted the silver, the damask cloth with its embroidered initial, and even the tea sandwiches. This painting has been exhibited several times at the Newport Art Museum and at the Museum of Art of the Rhode Island School of Design.

171. Olive Bigelow Pell

AMERICAN, 1886–1980

Tanya and Sandy Holmsen, 1932

Oil on canvas, 42 by 52 inches
Collection of John Holmsen Brainard

Olive paints her two grandchildren here with their hobbyhorse and other toys. Her style of painting continues to reflect her interest in illustration.

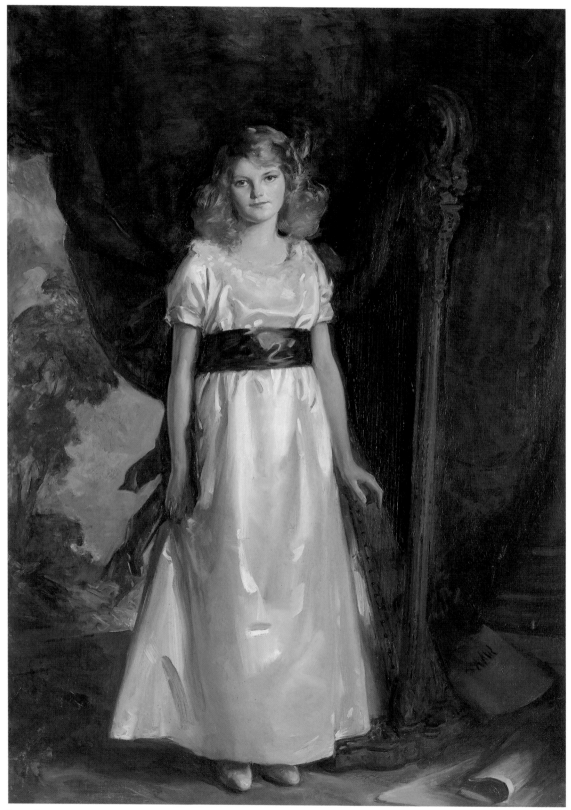

Doris Duke was active in the restoration of many Newport houses during the 1970s. She created the Newport Restoration Foundation, which owns and maintains seventy colonial homes. Her collection of eighteenth- and nineteenth-century furnishings is in the Whitehorn Museum in Newport.

Wilfred Gabriel de Glehn

ENGLISH, 1870–1951

174. *Mary Pope*, 1930

Oil on canvas, 21 by 25 inches

175. *Jane Pope*, 1930

Oil on canvas, 21 by 25 inches
Collection of Mrs. Thomas Ridgway

Mary and Jane Pope were the daughters of the well-known architect John Russell Pope. Pope's designs include the Jefferson Memorial and the National Gallery of Art in Washington, D.C. In Newport, he designed his summer residence, The Waves, built on rocks overlooking the Atlantic Ocean at the end of Ledge Road. His daughter Mary died shortly after the paintings were completed. Jane Pope became Mrs. Thomas Ridgway of Newport.

Wilfred de Glehn was born in London and studied at the Kensington School. He continued his studies in Paris with Gustave Moreau at the Ecole des Beaux Arts. In America, de Glehn worked with both Edwin Austin Abbey and John Singer Sargent on murals for the Boston Public Library.

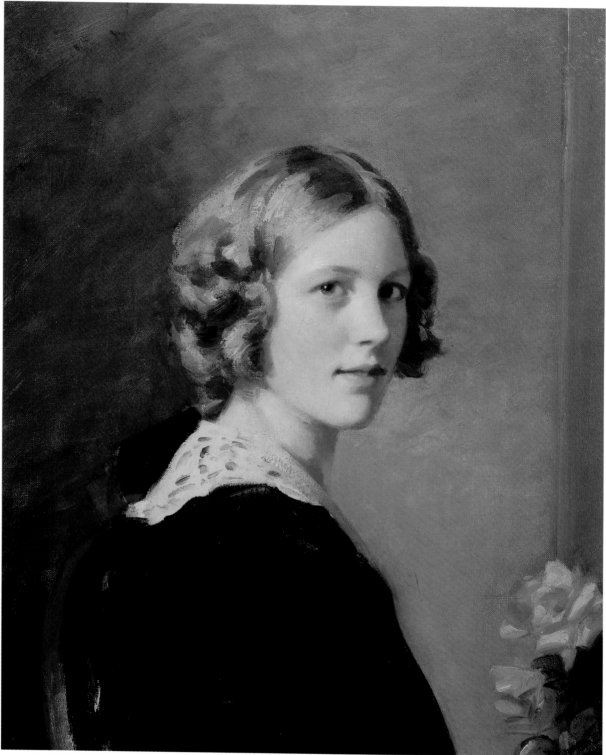

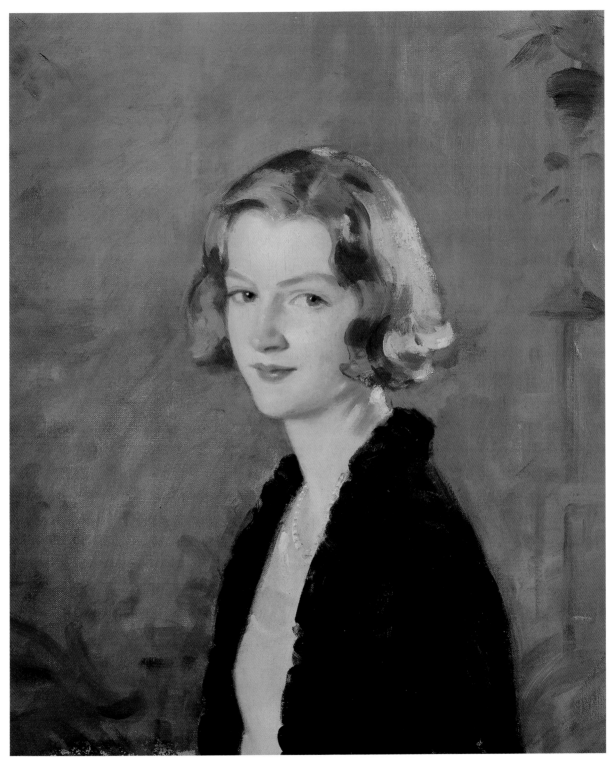

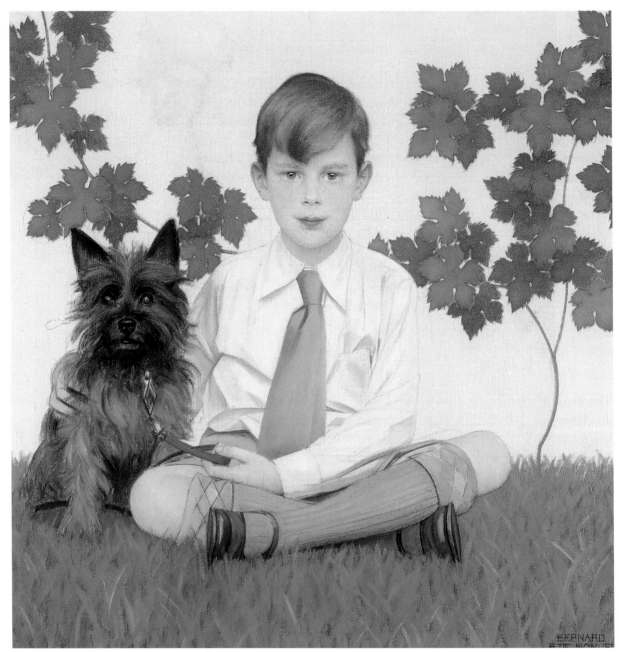

190. Channing Hare

AMERICAN, 1899–1976

Barton Gubelmann (Mrs. Walter S. Gubelmann)

Oil on canvas, 30 by 26 inches
Collection of Mrs. Walter Gubelmann

Channing Hare created a less dramatic portrait of Barton Gubelmann, another active member of Newport's summer colony. Mrs. Gubelmann, widow of corporate executive and yachtsman Walter Gubelmann, is shown in a head and shoulders profile image. It is painted with the same realistic approach as the portrait of Mrs. Ingersoll (cat. 189). Here again, Hare relished the textures of his subject's formal attire.

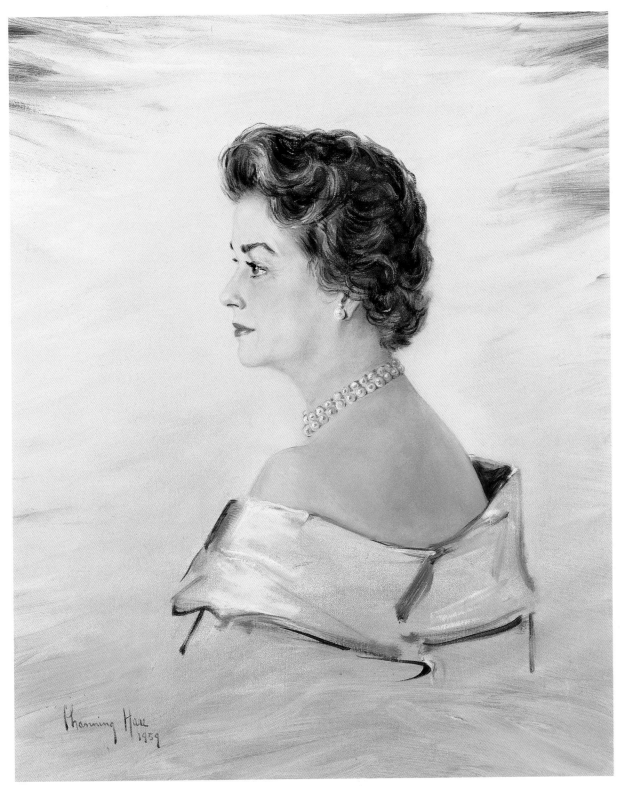

Channing Hare
1959

Patrons of Contemporary Artists: After World War II

POST-WAR NEWPORT included those who were intrigued by and supportive of artists who had made their names on the international art scene, such as Salvador Dali and Diego Rivera, as well as by those who were helping to make New York the new center of the art world, including Richard Lindner, Andy Warhol, and Larry Rivers. These artists, very much in the forefront of the rapidly developing movements of their time, stepped out of character to do these portraits. Through these commissions, Newporters supported a new legion of avant-garde artists.

191. Salvador Dali

SPANISH, 1904–1989

Josephine Bryce, 1946

Oil on canvas
Private collection

Salvador Dali, the great Spanish proponent of Surrealism, is far less well known as a portrait painter. In 1941, a major exhibition of his work was held at the Museum of Modern Art in New York City. Dali spent the next fifteen years in the United States, and during this time, he turned to portraiture.

This portrait of Mrs. Bryce shows Dali's extraordinary skill at rendering details in a super-realistic manner. The background is a fanciful landscape, peopled by tiny figures of musicians and by Don Quixote with Sancho Panza, an allusion to Mrs. Bryce's support of the arts.

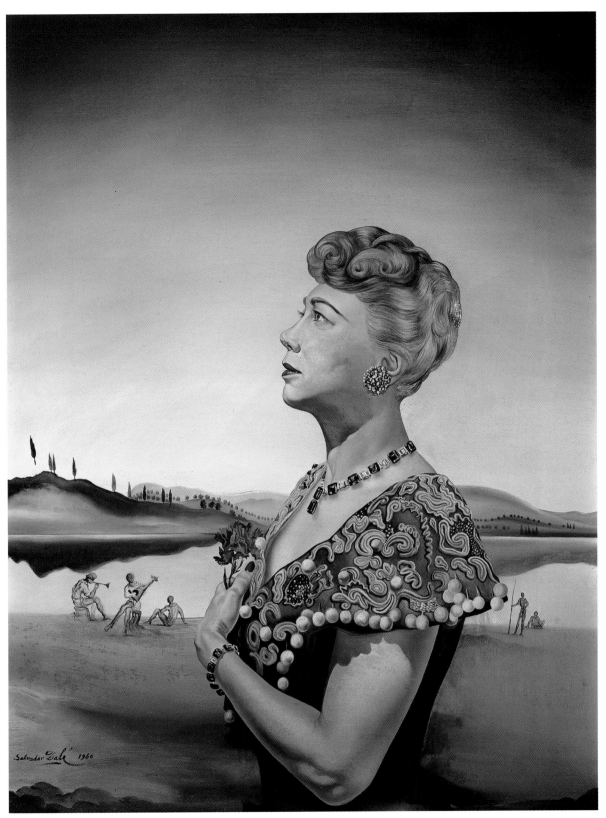

Painted in profile, the portrait's composition is reminiscent of the Renaissance portraits of Piero della Francesca and Uccello. The dress and jewelry are painted in sharp detail. In the subject's hand is a carnation, a traditional symbol of wifely faithfulness.

Mrs. Bryce, the mother of Mrs. Claiborne Pell, died in 1992.

192. Diego Maria Rivera

MEXICAN, 1866–1957

"Titi," Princess von Fuerstenberg, 1955

Oil (?) on canvas
Collection of E. J. Hudson, Jr.

Diego Rivera is considered the leader in the Mexican mural renaissance of the 1920s and the 1930s. His work was political in nature and dealt with large social issues. It is therefore interesting to see examples of his work as a portrait painter. Rivera created portraits of the two Hudson children. Titi, shown here as a blond and sunburned young woman, is painted in brilliant colors and with free brushwork. She is now Her Serene Highness Princess Tassilo von Fuerstenberg and resides in Monaco. Her family has a summer home in Newport.

193. Diego Maria Rivera

MEXICAN, 1886–1957

Jojo (Joseph Hudson), 1955

Oil on canvas
Collection of E. J. Hudson, Jr.

Titi's younger brother is presented in a highly decorative composition, in which he is dwarfed by a large arrangement of calla lilies. Toys are scattered on the floor in front of him. With its large planes of color and nonpainterly brushwork, this portrait relates more closely to Rivera's mural style than his painting of Titi (cat. 192). The Hudson family maintains a summer home in Newport.

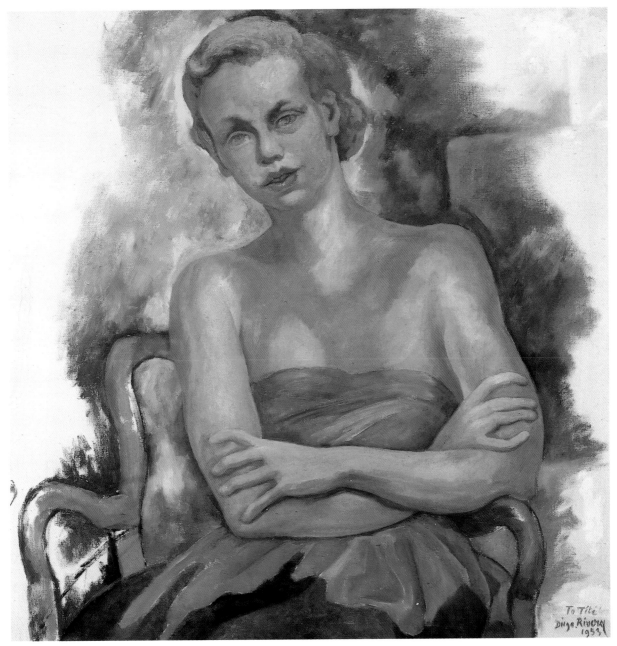

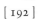

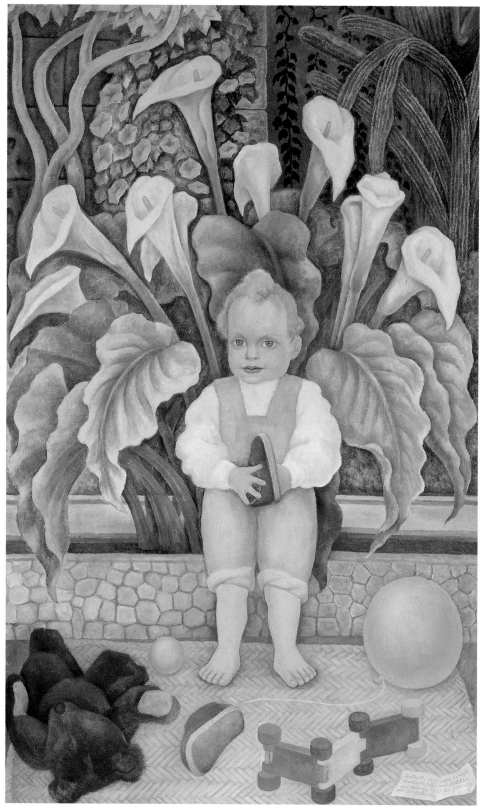

194. Larry Rivers

AMERICAN, BORN 1923

Portrait of the Princess (Titi Hudson in Blazing Pink), 1982

Acrylic on canvas
Collection of Princess von Fuerstenberg

Once again, an avant-garde artist has painted a portrait of the princess. Larry Rivers was part of the New York school of abstract expressionists during the 1940s and 1950s. His work reflects the period's interest in action painting, in which the artist makes the viewer aware of the manner in which he lays down his pigments. The princess is "drawn" in black on a large area of pink, which connects the chair in which she is sitting with the background. This canvas once again reinforces our appreciation for the Hudson family's patronage of contemporary artists, providing them commissions and supporting their experimental styles.

195. James Rosati

AMERICAN, 1912–1988

Head of Lee (Lee Hudson), 1963

Bronze
Collection of Robert Lee Hudson

The Hudson family commissioned a more traditional rendition in this bronze head of young Lee Hudson.

196. Richard Lindner

GERMAN-AMERICAN, 1901–1978

Joan Reeves Lapham, 1970

Acrylic on canvas
Collection of Elizabeth B. Blake

This extraordinary portrait was painted by Richard Lindner in 1970. Lindner was born in Germany, trained as a concert pianist, studied painting in Nuremburg and Munich, then fled Nazi oppression. He first went to Paris, then to the United States, where he became a naturalized citizen. His paintings moved from scenes of New York streets to less naturalistic images with harsh colors and strong outlines. By the 1960s, his work fit roughly into the Pop Art scene.

Elizabeth Blake has been a collector and a patron of contemporary art for many years. She agreed to Lindner's suggestion that he paint her daughter, Joan. In the mood of 1970, Joan, exotically arrayed, wears a miniskirt and high boots. The painter also included a separate and quite realistic portrait of the young woman in a circle set against a harsh ochre background.

Index of Artists and Sitters

Illustrations are indicated by page numbers in italics.

Library of Congress Cataloging-in-Publication Data

Newportraits / Newport Art Museum.

 p. cm.

 Based on a 1992 exhibition at the Newport Art Museum.

 ISBN 1–58465–018–4 (cloth : alk. paper)

 1. Portrait painting—Rhode Island—Newport—Exhibitions. 2. Newport (R.I.)—Biography—Portraits—Exhibitions. 3. Newport (R.I.)—History—Exhibitions. 4. Portraits—Private collections—United States—Exhibitions. I. Newport Art Museum (R.I.)

 ND1311.9.N48 N48 2000

 757'.074'7457—dc21 99-44802